bearing witness

bearing witness (to AIDS)

Thomas McGovern

Visual AIDS | A.R.T. Press

©1999 by **Thomas McGovern/Visual AIDS**
All rights reserved
Published by **Visual AIDS/A.R.T. Press**

ISBN 0–923183–24–8

Major support for this publication was provided by
Dextra Baldwin McGonagle Foundation, Inc.
Helvetica Jones
Dr. Cantz'sche Druckerei
Additional support was provided by
Milton & Sally Avery Arts Foundation, Inc.
Visual AIDS for the Arts, Inc.
Art Resources Transfer, Inc. a.k.a. **A.R.T. Press**

First Printing

Requests for permission to reproduce material
from this work should be addressed to:

Thomas McGovern
c/o Visual AIDS
526 West 26th Street
No. 510
New York, New York 10001

212 627 9855
email visAIDS@earthlink.net

Visual AIDS is a not-for-profit organization which raises public
awareness of AIDS through the visual arts. By mobilizing
the visual arts communities, Visual AIDS raises money to provide
direct services to artists living with HIV/AIDS.

Art Resources Transfer, Inc., also known as **A.R.T. Press**, is a
non profit organization committed to documenting and supporting
artist's voices and work, and making these voices accessible
beyond conventional art spaces and outlets. As a result, A.R.T.
Inc. has developed a distribution program that places books on
art and culture into rural and inner-city libraries. The Distribution
to Underserved Communities (D.U.C.) Program makes essential
materials on the arts and culture available to anyone with a
library card. D.U.C. reaches readers in twenty states and to date
has placed 16,000 books in underserved communities.

The profits from the sale of this book will go towards establishing
a fund for artists living with HIV/AIDS, administered by Visual
AIDS. 1,000 copies of this book have been donated to libraries
through Art Resources Transfer's D.U.C. Program

Book design by
Garland Kirkpatrick/Helvetica Jones (helvjones@aol.com)
Santa Monica, California

Printed by **Dr. Cantz'sche Druckerei**
Ostfildern, Germany

for Renate

acknowledgments

First and foremost I am indebted to the men and women, their lovers, husbands and wives, their families and friends, who allowed me to photograph and interview them for this project.

This book is the result of the effort of many people and while I am sure that I will make some important omissions, I wish to thank the People With AIDS Coalition and their publication, the PWA Newsline, who published my first letter seeking volunteers for this project; Gay Men's Health Crisis for letting me volunteer; Marge Neikrug who first exhibited this work; John Montana M.D. who shared experiences about his medical practice; Jeffrey Wallach M.D. who shared experiences about his practice and who allowed me to photograph him with patients; Fred W. McDarrah, who early on saw value in the work and through his friendship and leadership encouraged me to continue and refine the project. Fred also gave me many opportunities to photograph aspects of the crisis and was invaluable in helping me to establish my professional credentials; Janet Riker at the Rotunda Gallery who arranged an early exhibition of the work; Dwan Reese at the Brooklyn Historical Society who, along with Robby Rosenberg, provided valuable access; Barbara Millstein at the Brooklyn Museum who has long been a supporter; Deborah Willis and later Mary Yearwood, who both bought many photographs for the Schomberg Center for Research in Black Culture; Lynne De Beer at the Chaffee Art Center; Verna Curtis at the Library of Congress; Carmel Scalese and Richard Joseph at the AIDS Council of Northeastern New York, who provided valuable access; Professor Martin Benjamin and Professor Walter Hatke at Union College; Professor Mel Rosenthal; Robert Newman who helped me understand the power of publication design; Allen Frame and Nan Goldin who exhibited my work; Eastman Kodak for a material grant; Patrick O'Connell; David Waggoner at A&U Magazine; Terry McGovern; ACT UP for their radical advancement of the issue; Nick Debs for his fine introduction and early support; Choire Sicha; my dear friends, C. T. Wemple and Pamela Parlapiano, who listened to me complain and helped me refine my work; Kim Abeles who was instrumental in getting the book distributed;

Ian Spanier who helped me find financing; Mr. David Spanier, Mr. Maury Spanier and Mr. Jonathan Spanier, who maintained their belief in the project for two years; Stephen Kelsey of Hackney Press, London, for his professional advice and encouragement; Lutz Hieber and Gisela Theising for having purchased and exhibited my work and for their continued support; Liz Lachman and Peter Dietrich for their friendship and generous offer of assistance; Gordon Fuglie at Laband Art Gallery at Loyola Marymount University for organizing an exhibit of this work.

Thanks to my co-publishers — Barbara Hunt, Executive Director of Visual AIDS, for her invaluable guidance and professionalism over nearly two years and Bill Bartman, Executive Director of A.R.T. Press, who arrived in the nick-of-time with professional support and distribution. Special thanks to the foundations and organizations that funded this project — the Dextra Baldwin McGonagle Foundation, Inc. for their early and very generous support; the Milton and Sally Avery Arts Foundation, Inc.; and Dr. Cantz'sche Druckerei, Ostfildern, Germany for their professional and generous printing services.

Garland Kirkpatrick deserves special mention not only for his powerful design but also for his profound understanding of how design and typography further the intention of the artwork. He will deny it, but I feel that he advanced my own vision of this work and aided my understanding of what this book could be. Calvin John Lowery provided a personal connection between Garland and myself and his memory was a significant factor in the design of this book.

My friends and colleagues at California State University, Fullerton, who provide advice and loving support, especially Eileen Cowin, Jade Jewett, Darryl Curran, Joseph Santarromana and Tim Wride.

My family and especially my parents, John and Ona, who taught me the values of compassion and persistence.

Finally, my beloved wife Renate, who encouraged, supported and challenged me every step of the way.

Thomas McGovern
Los Angeles

preface

The history of AIDS has yet to be completed; it is an unfinished and ongoing tragedy endured by peoples across the world and yet, surprisingly, still ignored by the majority of citizens in Western societies. Since the invention of the camera, photographic documentation has borne witness to history for future generations, giving subjective, momentary viewpoints and visual testimonies of those who have lived it. Without these silver gelatin "voices," the visual companion to the written word, the full story of the AIDS pandemic can not be understood — its impact on real peoples' lives, its sadness, its fullness, and the courage of those affected by it.

Photographs from the past enable us to try to imagine what that time was like, how were these people different from, or similar to, you and I? These photographs by Thomas McGovern are conspicuous for their truthfulness (in as much as this can be said of any photograph) and the honesty with which these people with AIDS open their lives to our scrutiny. Speaking directly to us, and to history, they ensure that a record is kept and that their voices can teach others about one of the most significant pandemics civilization has known. We can share in their experiences without voyeurism, a danger for any documentary photographer tackling this difficult subject. Instead we feel that these are, or could be, our families — our lovers, our sisters, our parents and our brothers. This is what mainstream society manages to overlook, too easily turning away in smug disdain, "this will never happen to me or mine." This is also the strength of this work, in fracturing this seemingly impenetrable belief and bringing empathy for sorrow endured by others. These are real families and real people who do not fit the media stereotypes of people with AIDS. They tell their own stories, stories which we can all relate to, and which we try to understand. To complete this project without veering toward the sentimental or the shocking is no small undertaking, and the photographer should be commended for the powerful and beautiful images which he presents here, alongside a clear sympathy and compassion for the people he has interviewed.

It could be said that Bearing Witness both is and is not, a "coffee table" photography book. It is indeed a stunning visual photo-essay on the lives of people living with AIDS, and as such, perhaps fits the definition that has become ascribed to these dramatic photographic publications. Yet I strongly believe that McGovern's work overcomes the trivial implications that have come to be associated with the phrase, and I consider this volume to be one that will be treasured and stored safely not a book to flick casually through, but one to value, to consider, to read, and remember.

I wish to thank Thomas McGovern for bringing this project to Visual AIDS and for his perseverance over the course of two years through the maze of match funding and his successful search to find enough collaborating partners to realize the publication. Special appreciation goes to the funders and collaborators in the project, particularly the Dextra Baldwin McGonagle Foundation, Inc., for their early belief in the work, and without whom the publication could not have occurred. Also the Milton and Sally Avery Arts Foundation, Inc., whose early grant gave the project added momentum. Our co-publisher, Bill Bartman at Art Resources Transfer, who came to our rescue in providing publishing expertise and distribution deserves recognition. Nick Debs, the former Executive Director of Visual AIDS encouraged Tom from the start and conceived the initial collaboration; we are grateful for his excellent introductory essay and I am personally indebted to him for his continuous support and guidance. Particular thanks go to Dr. Cantz'sche Druckerei, Ostfildern, Germany, for their sponsorship of Bearing Witness. Finally recognition must go to Garland Kirkpatrick, the designer, who extended Tom's original vision for the book and created the object you now hold. On a final note, I wish to thank Rebecca Price, Assistant Director of Visual AIDS, as well as the many interns and volunteers, donors and foundations, without whom Visual AIDS could not survive on a daily basis.

Barbara Hunt,
Executive Director, *Visual AIDS*

foreword

Anger and its fallout make up much of the subject matter of the best of all the arts from any culture in any time; "anger" is the first word of the *Iliad*. Not coincidentally, anger makes good journalistic copy. That anger has been so central a factor in the "story" of AIDS might mean a lot of outstanding art/journalism about the pandemic. To a degree, this is the case, even given the fact that many who would create work about the disease have been killed by it. Nevertheless, I believe that much of the work "about" AIDS has suffered from the divorce of art from journalism, and vice versa.

The incompetence with which we have "greeted" AIDS (the usage is oddly reminiscent of the ancient Chinese formalities used to discuss smallpox), is the central cause of a tragedy that continues globally. This incompetence (pride?) has itself generated the anger of fantastic dimension that has carried much of the epic of AIDS activism of the past sixteen years.

Certainly coverage of the pandemic, especially in its early stages, reflected a complete failure on the part of journalists to report accurately what was happening. This failure was due, at the base, to an overweening pride on the part of those who wrote the news in believing that their view of the world was objective. In fact, it was abundantly obvious that their views were predicated on a battery of societal prejudices concerning sexual orientation, class, gender and race.

"Fine art" concerning the pandemic has often been detached from the realities of AIDS. Metaphor has been used to describe poetic circles around the subject, without addressing it. To a degree, this is due to an outmoded lack of faith in description. Ironically, this lack of faith, valuable as an antidote to believing that whatever one is shown is truth, can lead to paralysis when making art. This is especially true when one is making art "about" something as immediate as catastrophic disease or death. The too jejeune decorum with which many artists have treated AIDS, the white-bread periphrasis which has obscured the heart of the matter, is typical of our culture, and is shocking. It is especially shocking in that this poetic distancing is unintentional—I am sure that most artists who have made work "about" AIDS would vehemently disagree with me, and would maintain that their work is a "shocking indictment" of our culture. In fact, such work is fully enmeshed in the culture which it attempts to condemn.

Of course, works of art/journalism are always engaged in the culture which produce them. But there is a difference between *enmeshed* and *engaged*, and it is the consciousness of the line between the two that defines fine work from poor.

Thomas McGovern's photography is such fine work. Since 1987, he has been simultaneously documenting the course of AIDS as a disease and social phenomenon while tracking its effects on the lives of individuals. He has maintained the eye of both journalist and fine art photographer. While acknowledging his engagement in some sort of American culture, he has been able to retain an autonomous stance which is not *merely* reactive.

A great deal of the power of Tom's work comes from the seeming coolness with which he approaches his subject. He makes full use of photography's claim to scientific verisimilitude; seemingly, these are pictures of events *exactly as they happened*. There is no loss of faith here in the power of "straightforward" depiction. Tom realizes the importance of the attempt to record history as it occurs, without hypocritically second guessing one's own intentions.

At the same time, these photographs are not *just* frozen frames from the depressing moving picture that is history. The artist is very much present in his work. This presence arises from empathy with what he is seeing, which forces him to both attempt the description of events and people, and dictates what he is actually describing. In other words, it is the very prejudices, or tendencies, or predilections, or emotional baggage, or the entire person of the artist/journalist which actually permit the recording of history. In Tom's case, rather than fight all these previous factors, he allows them to operate unimpeded.

Of course, similar factors are what made early press coverage of AIDS so inadequate. The sad fact is that it is a question of individual personality as to whether such factors lead to a denial of truths, or their revelation. Human nature would seem to lean towards the former, and perhaps that is why anger is such a theme in life and art. It is a great misfortune that the humane awareness and empathy of people like McGovern are not valued more highly. If they were, the AIDS pandemic might have run an entirely different course. As it is, we are lucky to have Tom's work as an historical document and artistic spur.

Nick Debs

bearing witness

In 1986 I learned that a group of men with whom I had lived in college in the 1970's had all died from AIDS. They were gay and rented space to me in their large suburban home outside of Washington, D.C., and the news of their deaths left me shaken—not only because of my fond memories of them but because we had all participated in the promiscuous sex and drug use of the time. To this day I wonder why I was spared the fate of my friends.

Due to this unanswerable question I decided to focus my work as a photographer on people living with AIDS. As I met and photographed more and more people with the disease, I became struck with their diversity and uniqueness. I have come to feel that the stories I am told and the pictures that I make are precious objects and mementos of a rapidly changing time and place. My role has shifted from documentarian to historian and from observer to caretaker.

While I have photographed many aspects of the crisis since 1987, it is the portraits of people with AIDS that are central to this project and it is around these that the photographs of events revolve. One without the other is less complete, in terms of history and life, and so I ask you to view this project's elements, portraiture and reportage, as symbiotic. And it is within this relationship that the crux of the project is evident—it is the sense of waiting and the passage of time. It is this aspect which is central to understanding the crisis as I know it.

The work for this project has taken ten years and so the quotes and statements are necessarily dated. As with any dated material, circumstances change and people may not feel today as they did when I first met them. Sadly, some people pictured may have died or made important contributions that I'm not aware of, and so haven't mentioned.

Within the complexity of the crisis lies the political, and reading United States Senator Jesse Helms' 1995 remark that people with AIDS are such because of "deliberate, disgusting, revolting conduct" does not sit well with me. History will be the judge of disgusting and revolting conduct. Look into the faces that I am showing you and the fourteen-year-old from Missouri and the homosexual artist from New York seem more like members of a vanishing tribe than deviants from the Senator's treasured norm.

Thomas McGovern

Ron Dennis
New York City, August 14, 1996

Ron, 52, is one of the original cast members of A CHORUS LINE.
He has had AIDS for ten years and due to combination drug therapy,
HIV is undetectable in his body. Ron continues his acting career
and lives in Los Angeles.

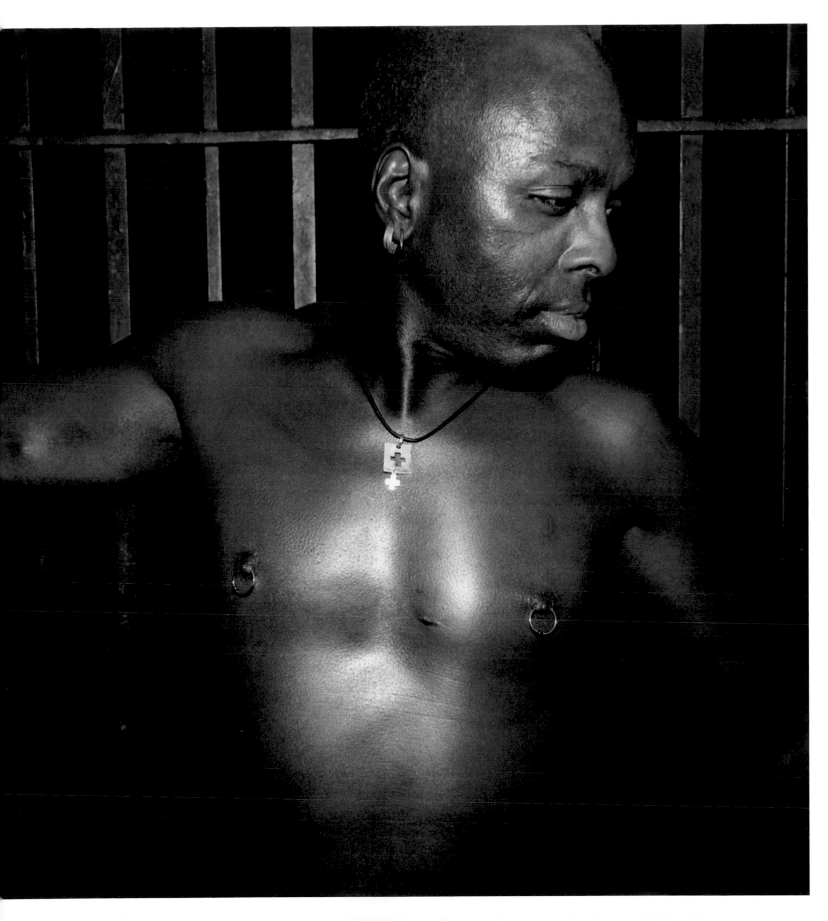

Sandi and Joe Terranova
Brooklyn, New York, March 19, 1990

Sandi is someone with a truly indomitable spirit.
When I first met her she began with an apology:
**"If I forget your name or what we're talking about,
just remind me because I'm suffering with dementia."**
She has had many manifestations of the disease and is also
recovering from treatment for cancer of the lymph gland.

Sandi is 44 years old, was diagnosed in 1988 and has two sons,
ages 7 and 14.

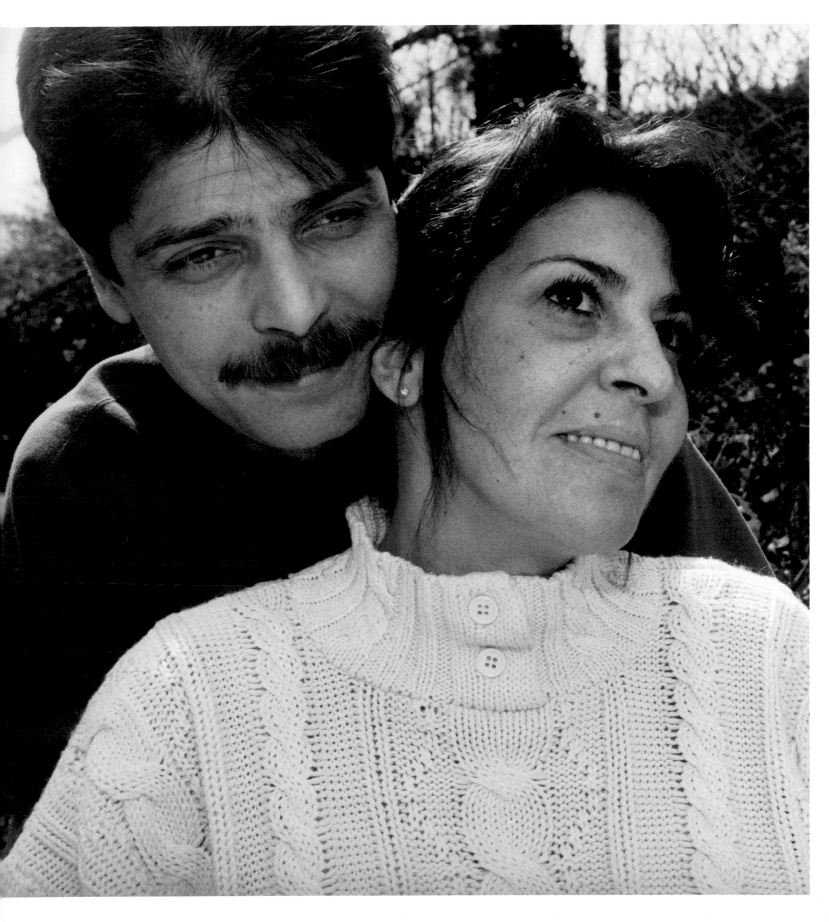

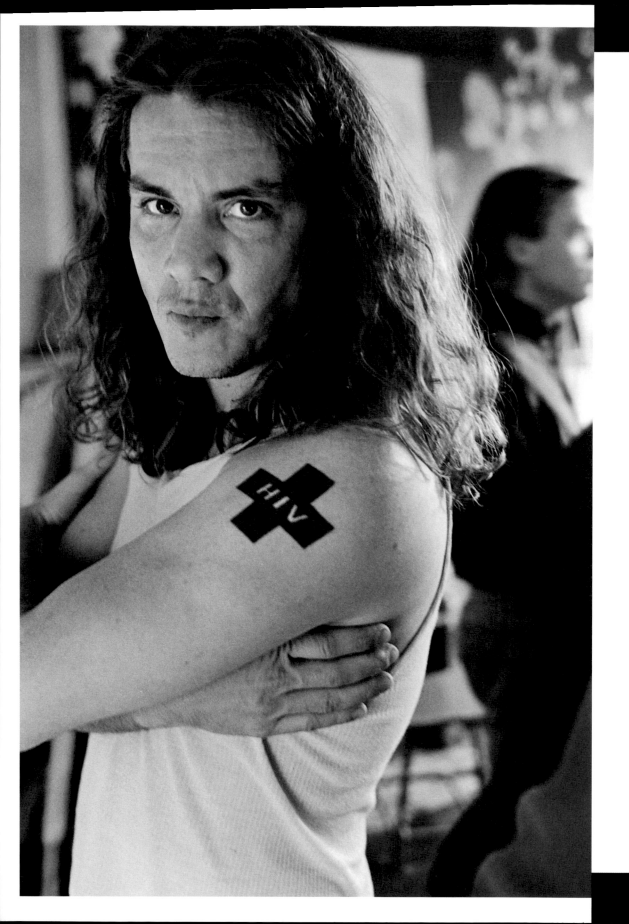

Bill Cullum
New York City, March 5, 1995

Bill, 37, is an artist and activist who is HIV+.

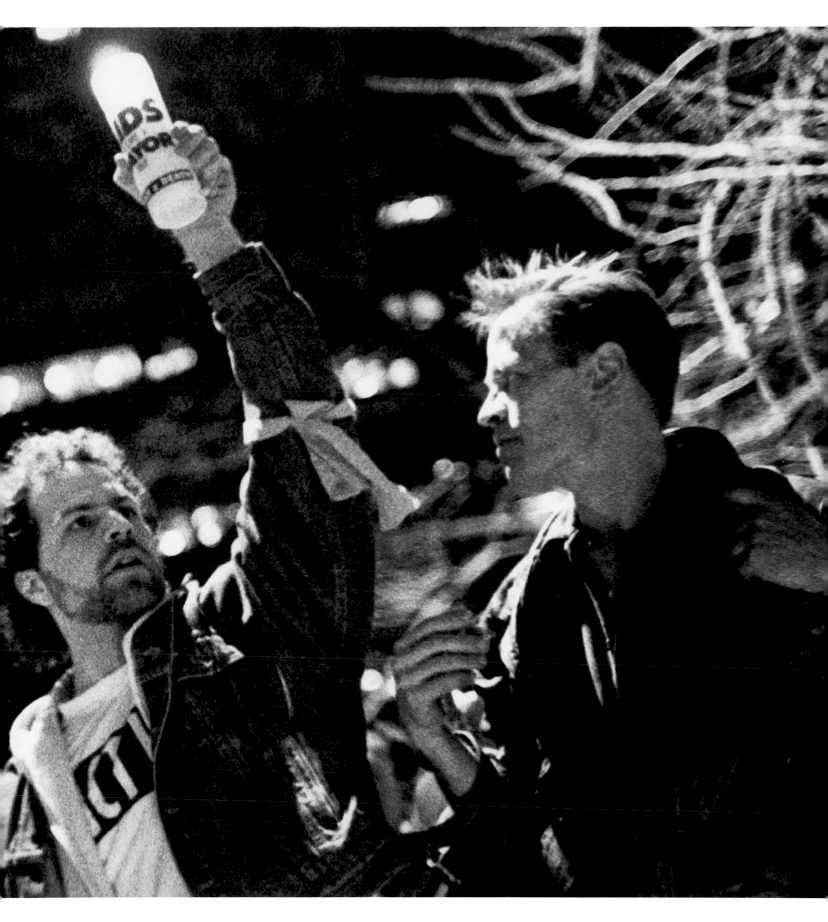

Donna Reed
Bayview Correctional Facility, New York City, September 20, 1989

My first contact with Donna Reed was from a letter in which she wrote:

Dear Tom,
I have just read your letter in the PWA-RAG (Prisoners with AIDS Rights Advocacy Group)
Newsline and am very interested in your project. I too want to help relieve some
of the stigma and ignorance associated with AIDS. I am a PWA and living proudly!

I am currently on AZT and pentamadine, I am having trouble eating which is actually
my biggest and worst problem. I do hope I can be of some service in any way possible.

Yours in the struggle,

Ms. Donna Reed
Albion Correctional Facility
July 4, 1989.

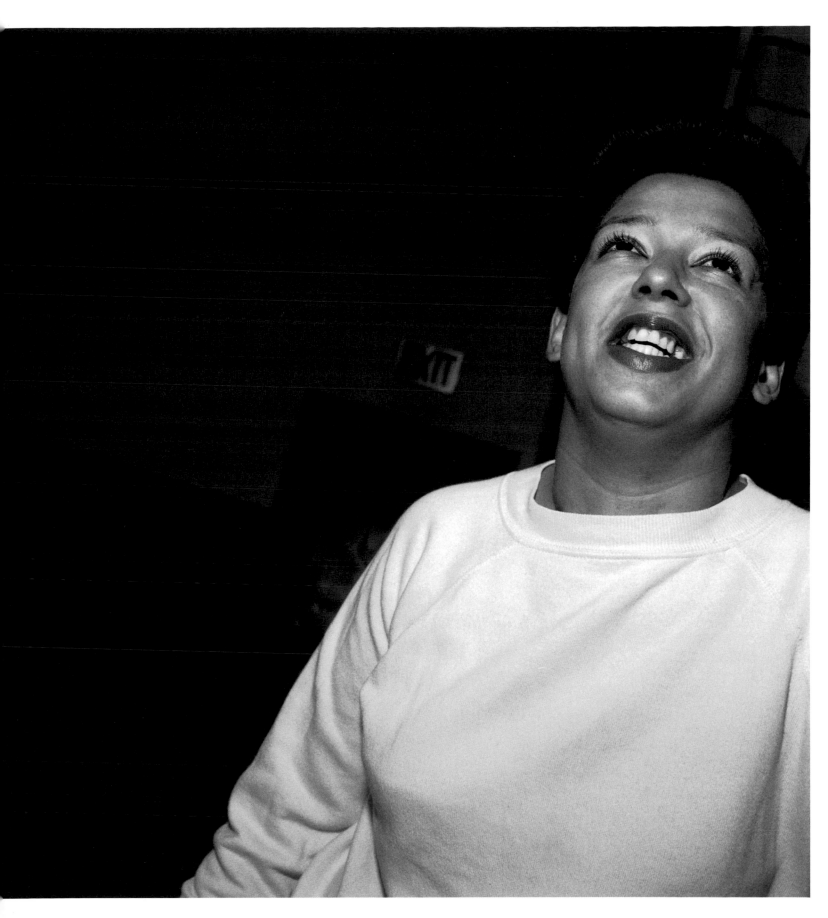

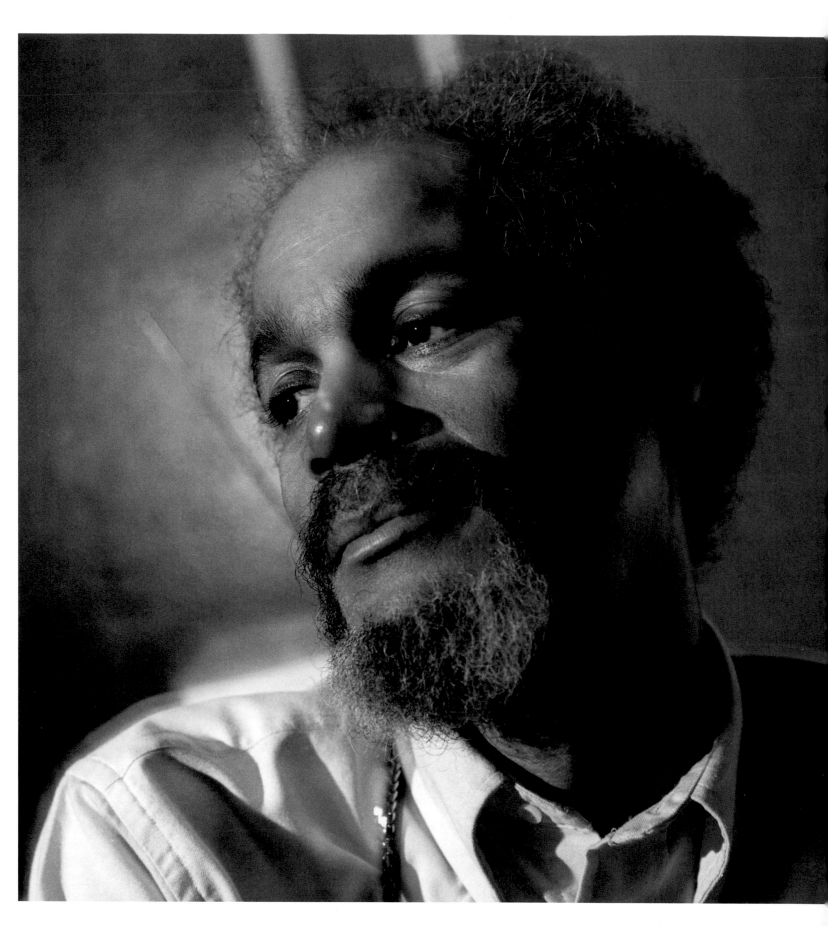

Phillip Coleman
Brooklyn, New York, December 26, 1992

Bruce Cratsley
New York City, 1995

Bruce was a photographer and Guggenheim Fellowship
recipient whose book, *White Light, Silent Shadows*,
was published in 1998.

Bruce was 53 years old when he died on June 29, 1998.

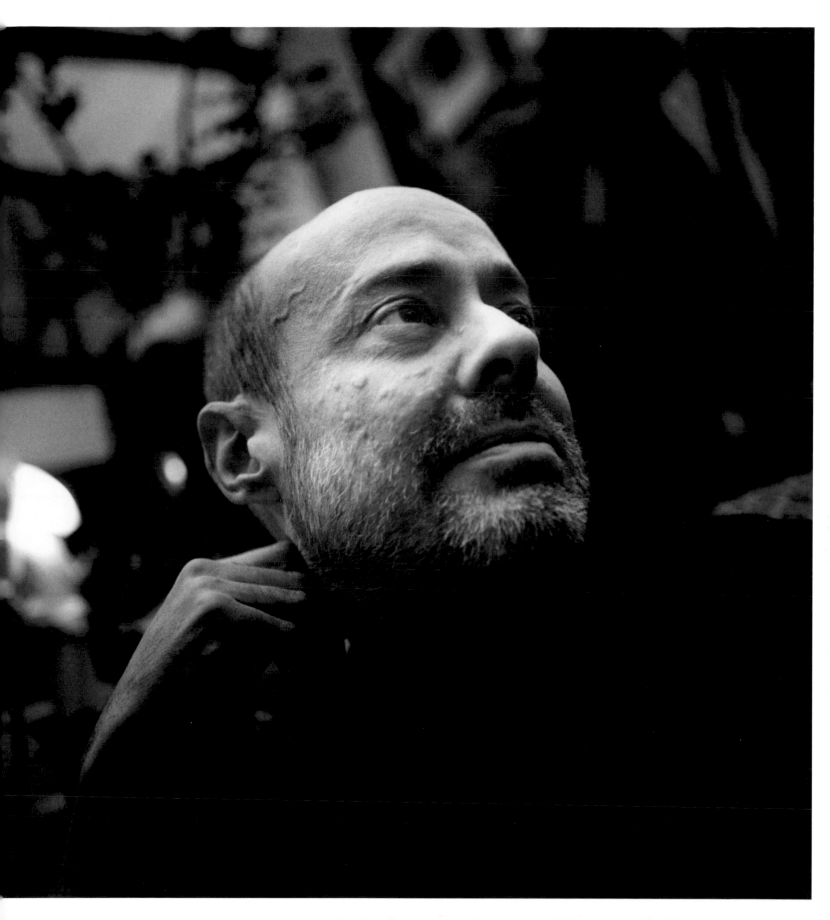

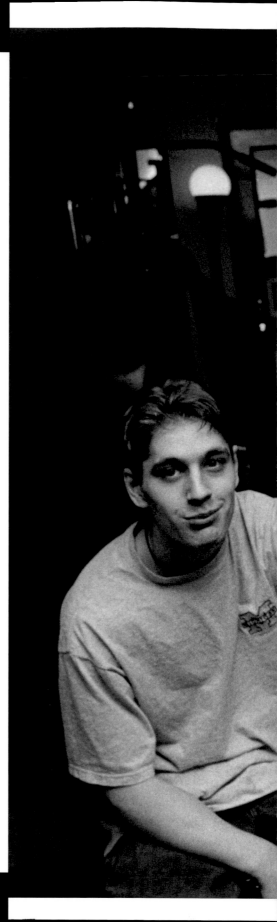

Ed Hatlee, 37, and son Christopher, 18
Albany, New York, March 29, 1996

Ed has been HIV+ and asymptomatic for ten years. He recently
began speaking about his experiences with HIV and is
particularly interested in helping to alert young people to the
dangers of the disease. Due to combination drug therapy,
HIV is undetectable in his body.

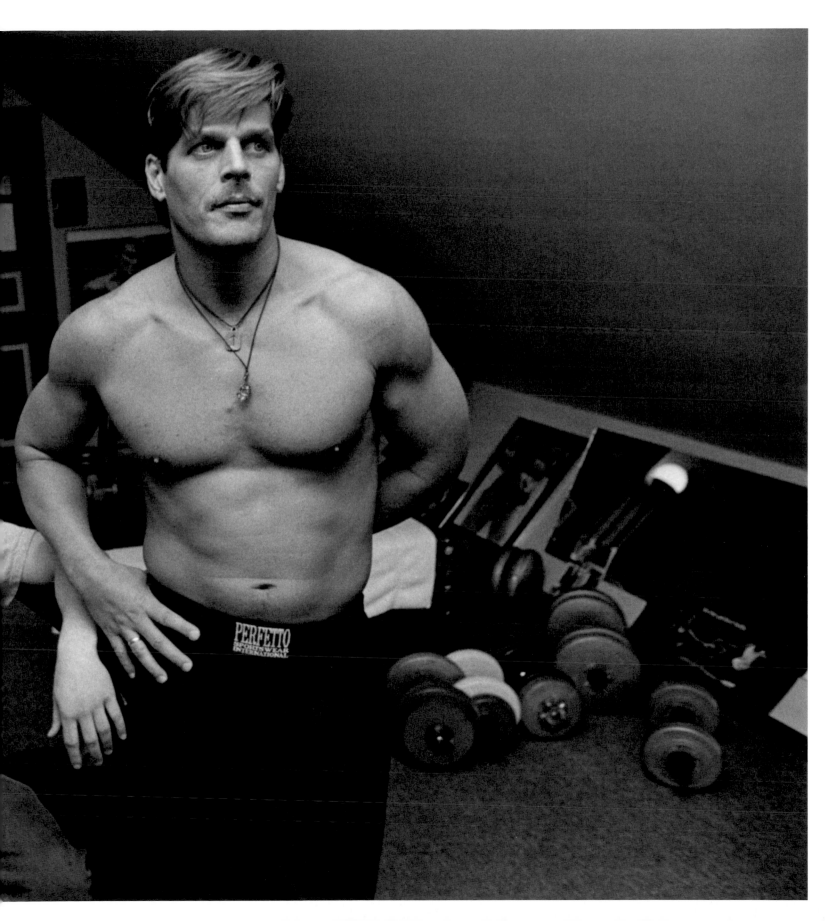

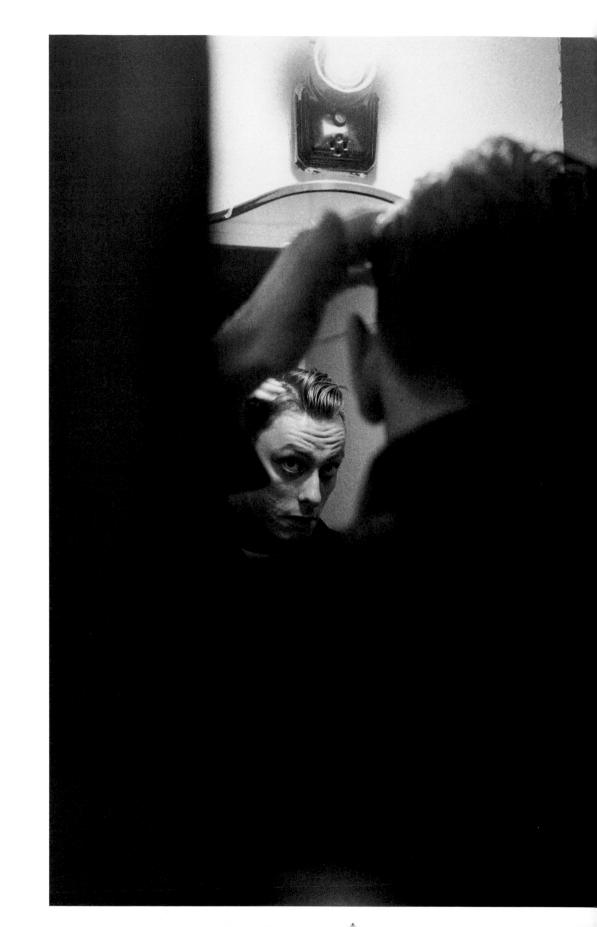

Judd Kopicki
New York City, December 10, 1994

Judd, 24, is a hemophiliac who has been HIV+ for ten years.
He is a clothing designer and does outreach, speaking
to young people about his experiences of living with HIV.

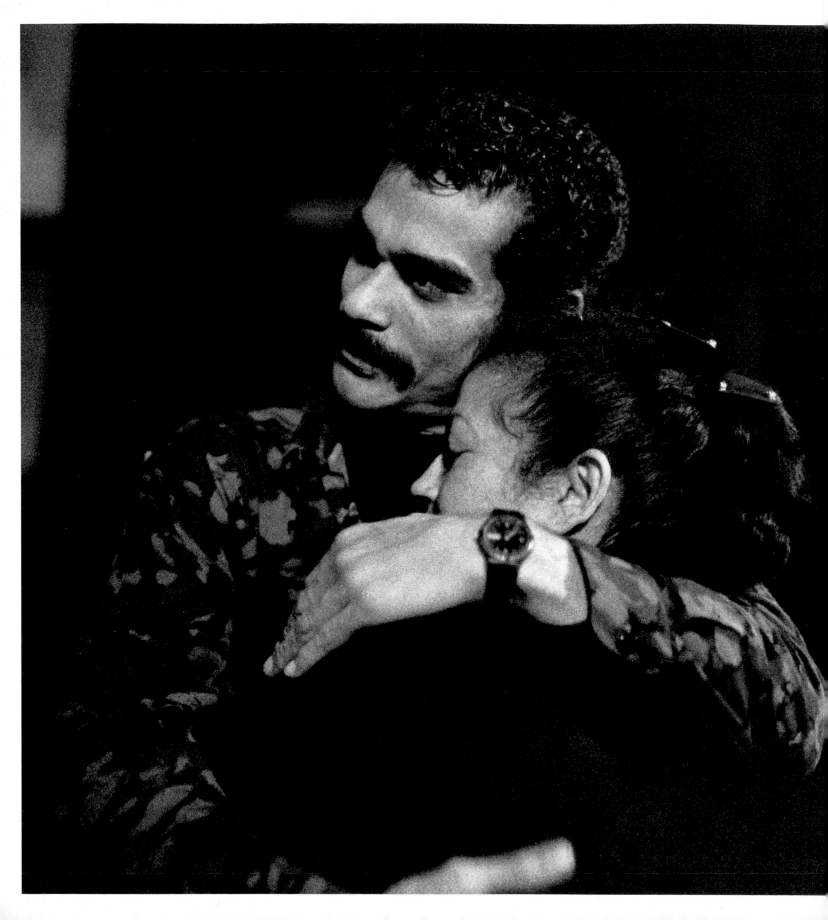

Peter Rodriguez
New York City, December 14, 1991

Peter Rodriguez holds his mother during a memorial service for his lover
Paul, and best friend Jeff, both of whom had just died from AIDS.

Shirley Campbell with Larry, Natisha and Rashad
Albany, New York, April 6, 1996

Shirley Campbell, 49, is a born-again Christian with AIDS and is
shown with her husband Larry (who is HIV– negative) and grandchildren.

Shirley told me: **"I live a good life. I can say I'm happier today with
HIV than I was when I didn't have it. It seems that God has given me a peace,
He has forgiven me. I know so many people who are lonely with this.
I can't help but feel good today because there are so many people who love me."**

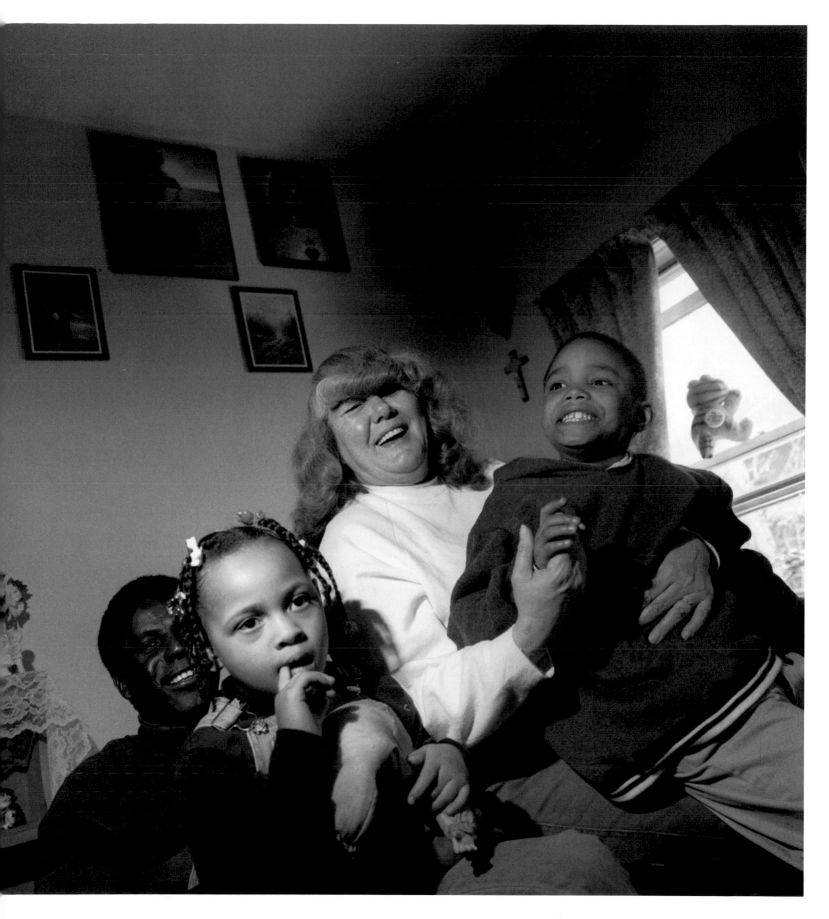

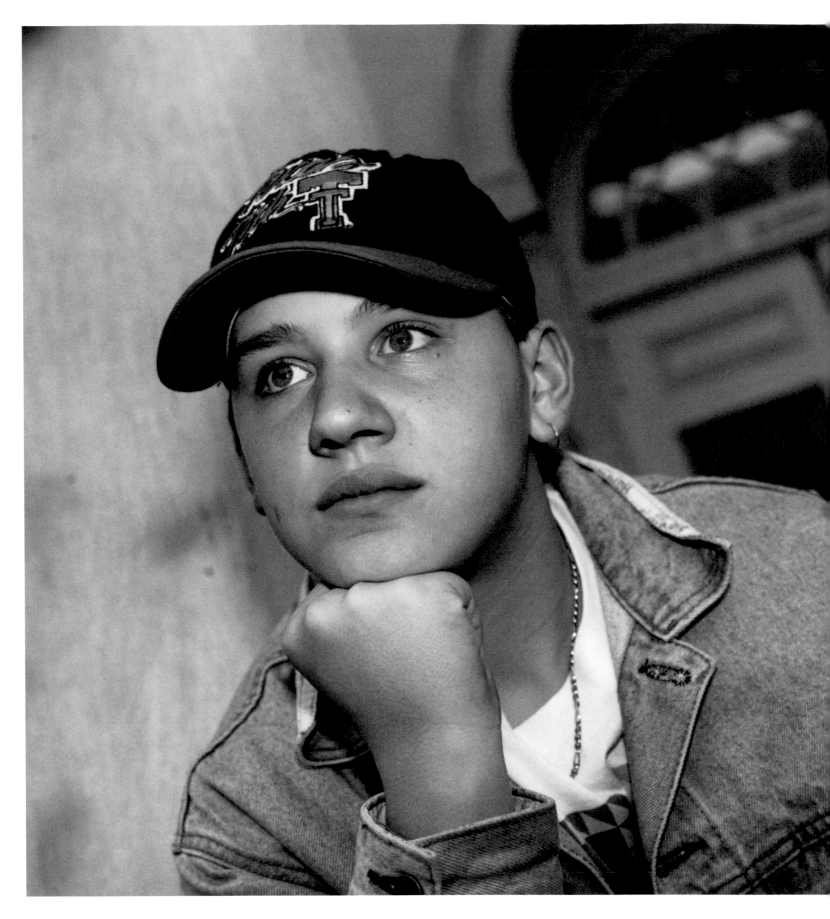

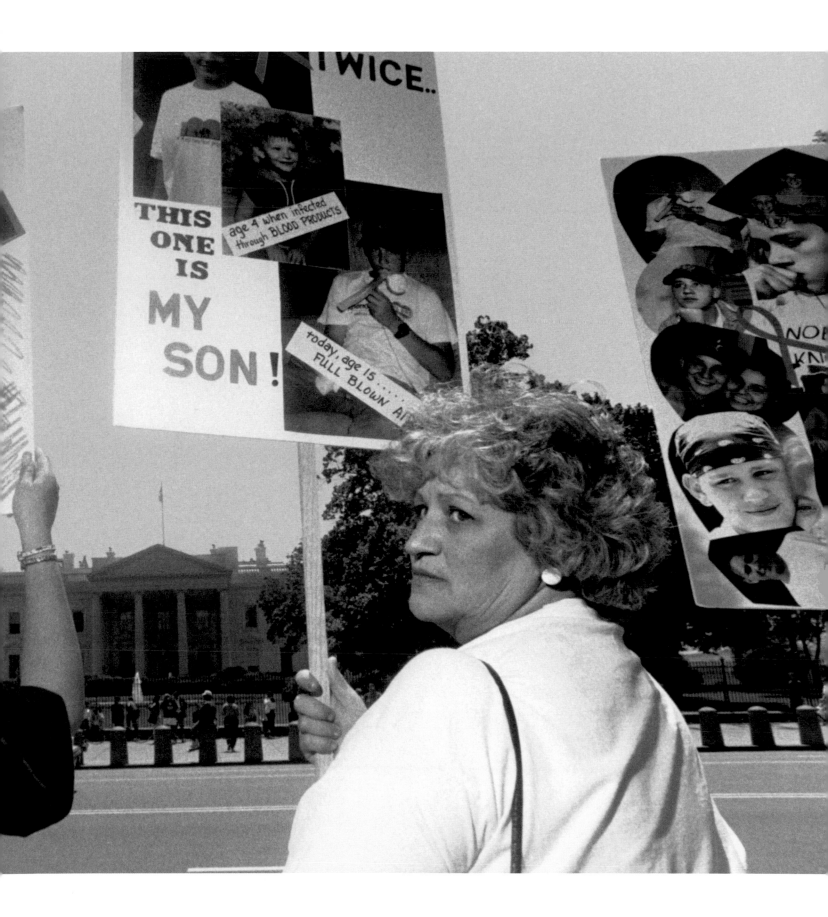

Annmarie Luciano and children Raquel, 7, and Peter, 11
Schenectady, New York, October 20, 1995

Annmarie's husband died five years ago and only after his death did she learn that it was from AIDS. Now she too has AIDS. Raquel doesn't seem to realize what this means but Peter is acutely aware of the impact on his family.

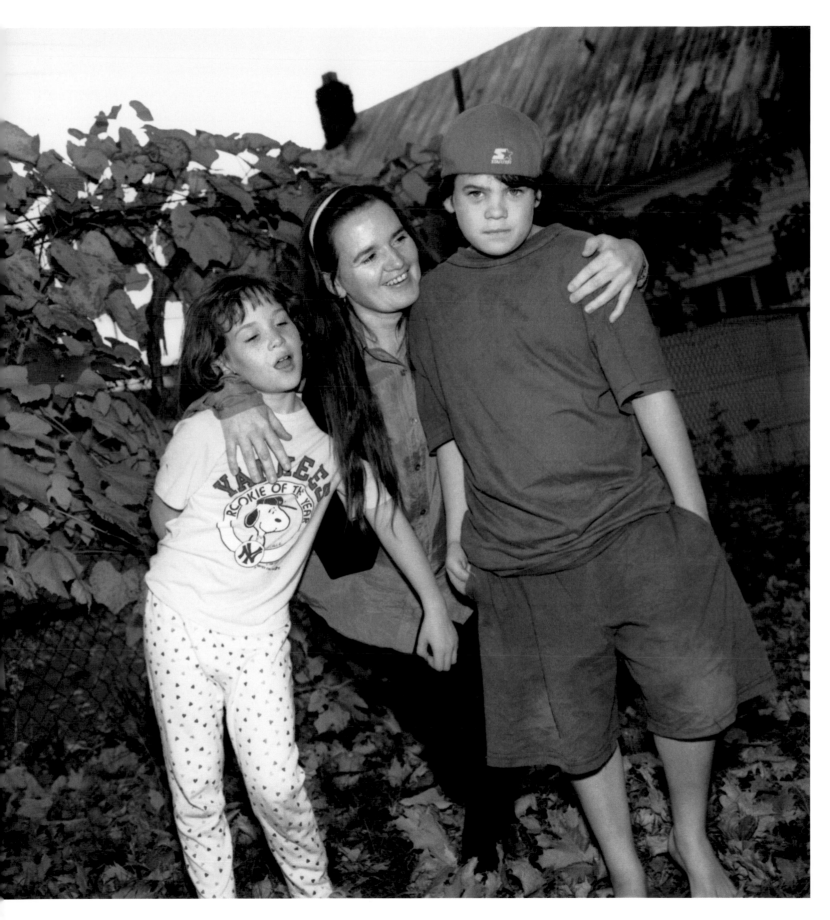

Brian Kane
New York City, November 20, 1987

Brian worked as a model before being diagnosed with HIV.
After his diagnosis, he began counseling runaway teens in
Times Square, New York.

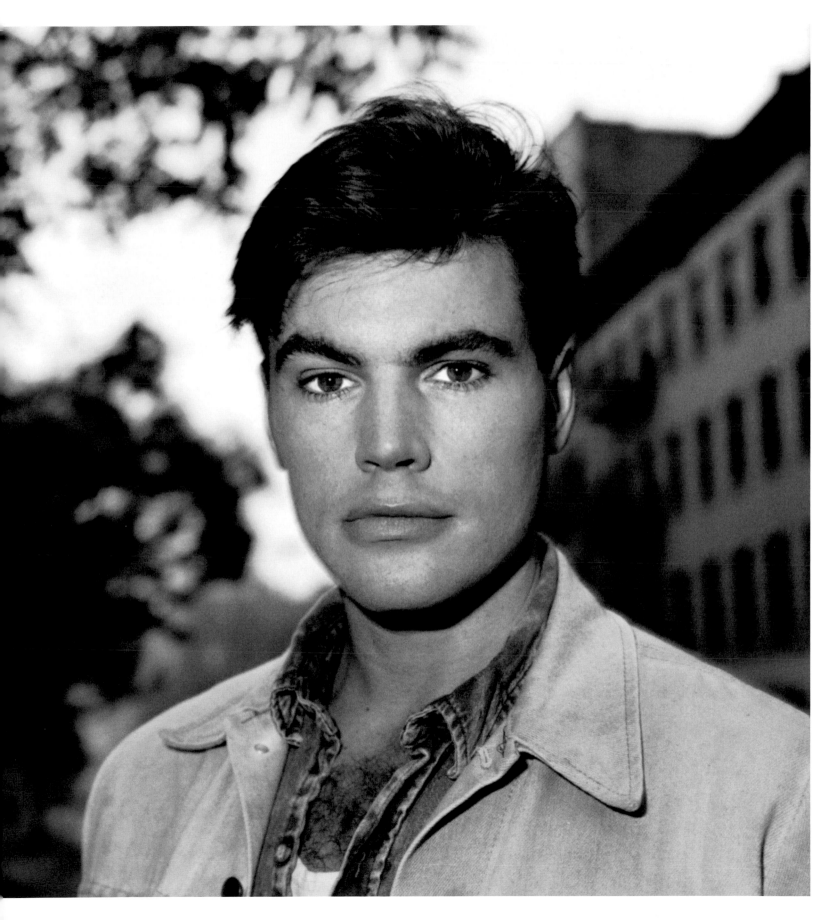

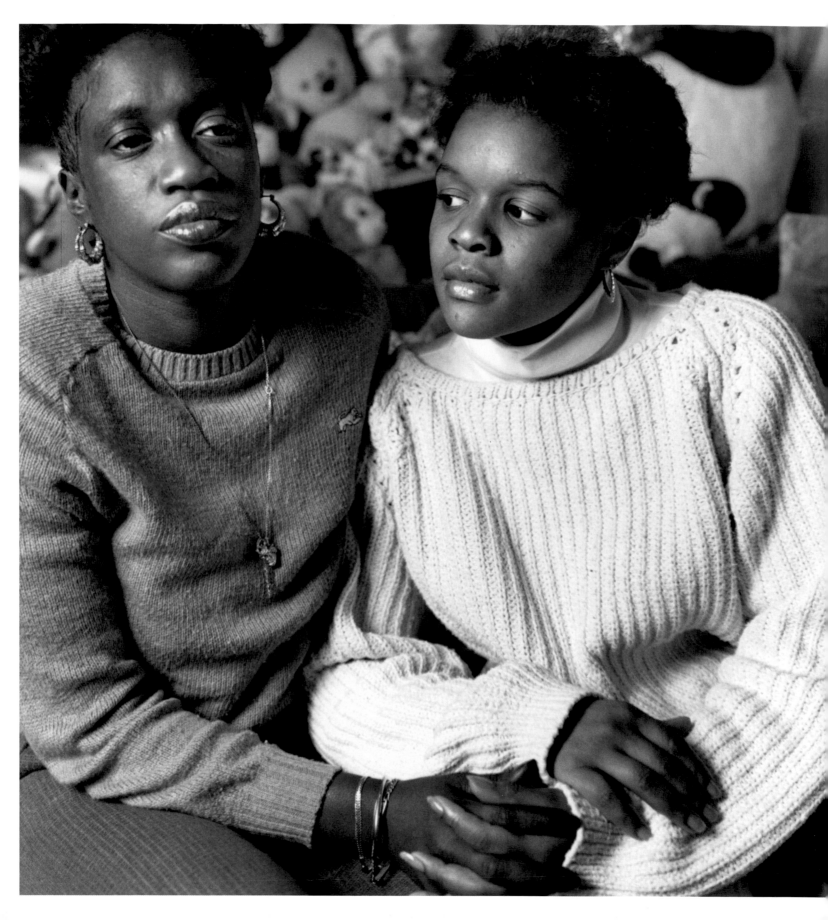

Verna Palmer and daughter Sheena
Bronx, New York, March 4, 1989

Verna wrote: **"My name is Verna and I'm a grateful recovering addict.
I have the disease of addiction but I also have another disease—
I have AIDS. When I found this out I was a patient at Silvis Grove
(a rehab center in Texas) and my Texas family was there for me.
Now that I'm home in the Bronx, my New York family comforts me
when I share my pain."**

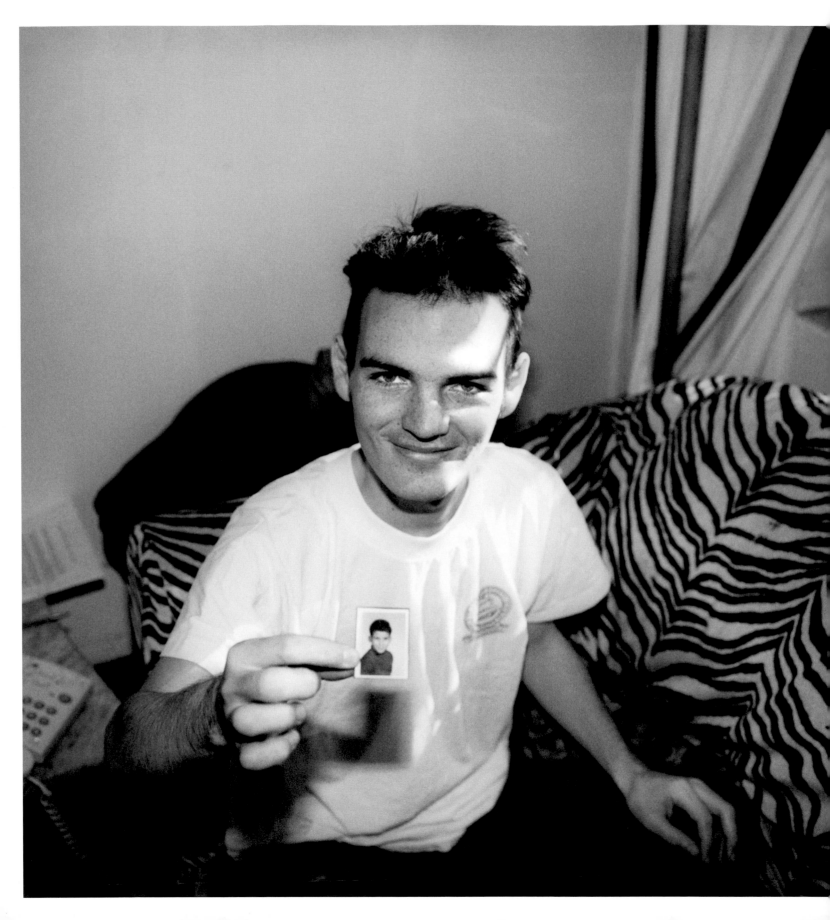

Byron Clayton

New York City, October 30, 1992

Byron talked to me about his lover, Allen, who died from AIDS in 1991.
He is holding a childhood school picture of Allen.

"Allen was very photogenic—big and gorgeous! We went and got tested
together but the day the results came back he was already ill. He went
to the hospital that night with **PCP**, recovered and was fine for a year.
Then in June, **1991**, his intestine ruptured due to an infection and
he had **PCP** as well as peripheral neuropathy and there were all these
things going on at the same time and it was really just too horrible."

"My family knows about my status and they've accepted that as much as
the unacceptable can be accepted...but I didn't tell them I had **AIDS**
until Allen died. Once Allen died I felt that there was no point in keeping
secrets anymore."

Byron died in 1993.

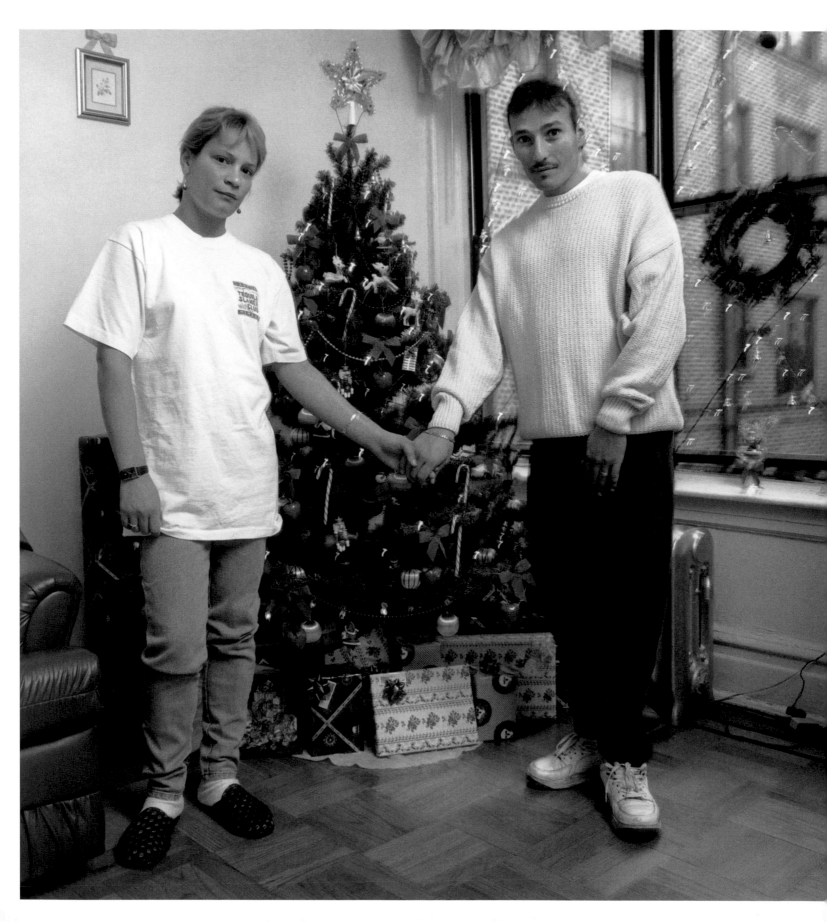

Diana and Hector Valentin

Brooklyn, New York, Christmas, 1993

Diana told me: **"Ever since I got sick it's like everything is so important to me, everything I do as if it's my last day. I live life to the fullest, but as time passes by you start feeling the symptoms, the fatigue and side-effects of the medication."**

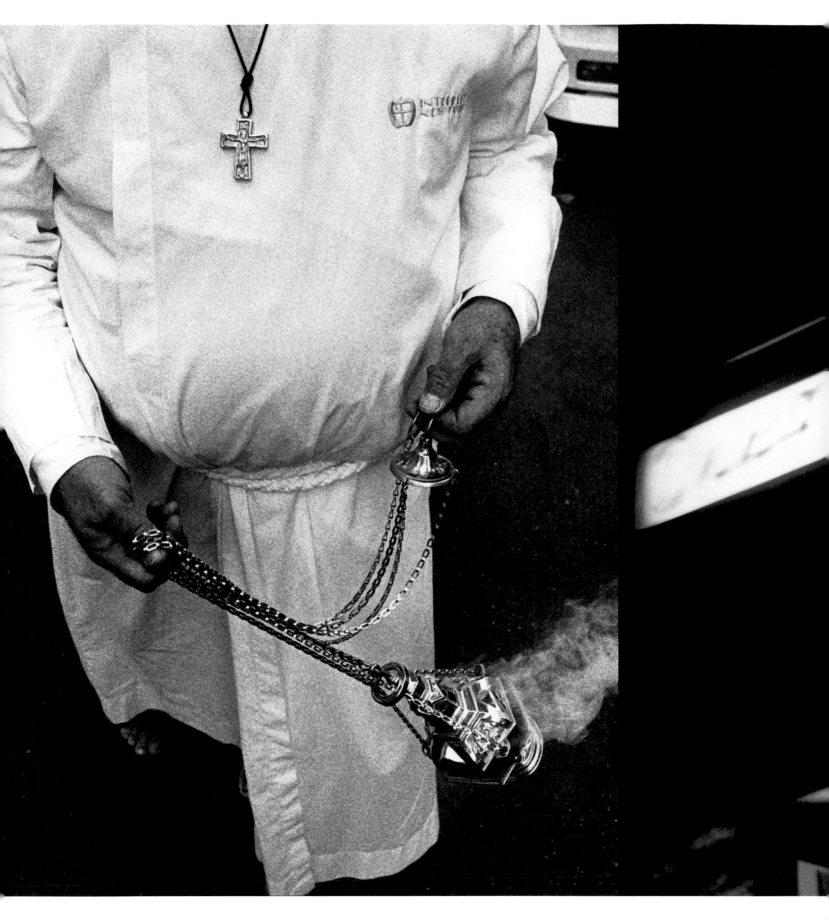

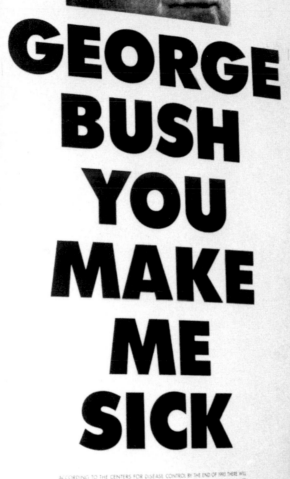

GEORGE BUSH YOU MAKE ME SICK

ACCORDING TO THE CENTERS FOR DISEASE CONTROL BY THE END OF 1993 THERE WILL BE OVER 340,000 AMERICAN AIDS DEATHS, OVER 480,000 PEOPLE ALIVE WHO WILL BE DIAGNOSED WITH AIDS ___ R 2,000,000 AMERICANS WILL BE INFECTED WITH THE HIV VIRUS. THE UNITED ___ THE ONLY INDUSTRIALIZED NATION IN THE WORLD BESIDES SOUTH AFRICA ___ NATIONAL HEALTHCARE SYSTEM, THOUSANDS DIE AND THIS GOVERNMENT DO___G, DEMAND A UNIVERSAL HEALTHCARE SYSTEM NOW.

ACT UP

© 1991 CRITICAL MASS

FOR MORE IN___ 669-7301

Gary Brown
New York City, January 7, 1988

Gary, a high school teacher in New York, moved back to his hometown,
Wichita, Kansas, to be near his family after being diagnosed with AIDS.

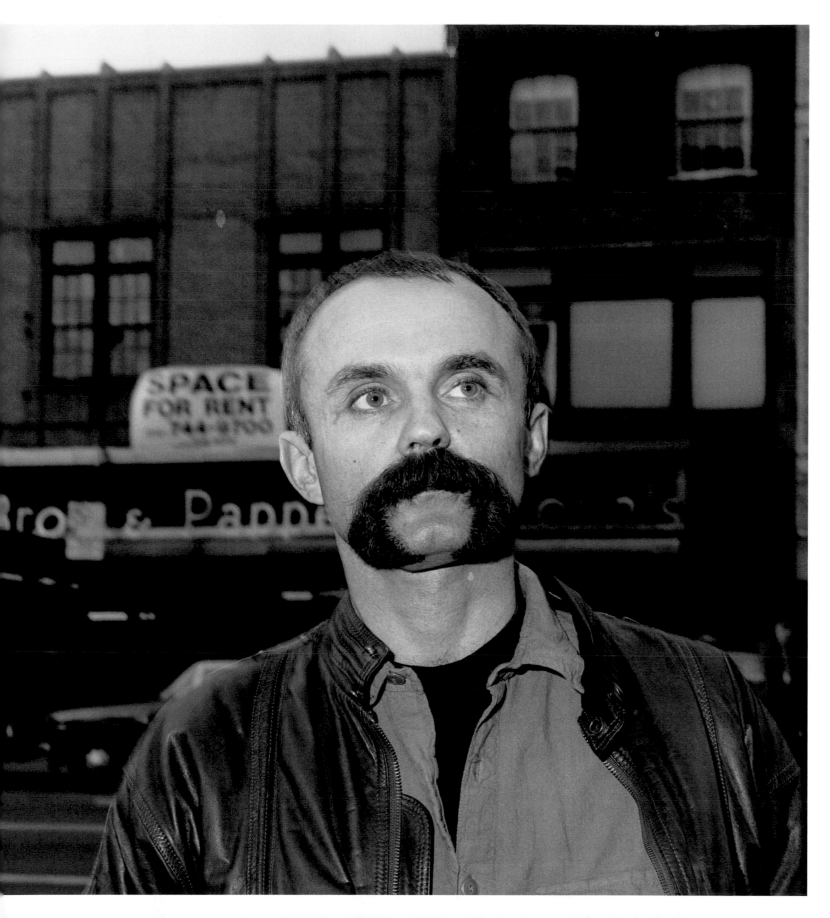

Geoff Edholm and lover Bruce Herman
New York City, August 10, 1988

Geoff wrote to me: **"I'm interested in your project. I've had AIDS
for two years, two bouts of pneumonia, TB, skin cancer and a host
of other things. I do well, look well and usually feel OK. I have
a volunteer buddy who helps me get about, but I live with my lover
and dog — perhaps they could be components of my portrait?"**

Geoff died in early 1989.

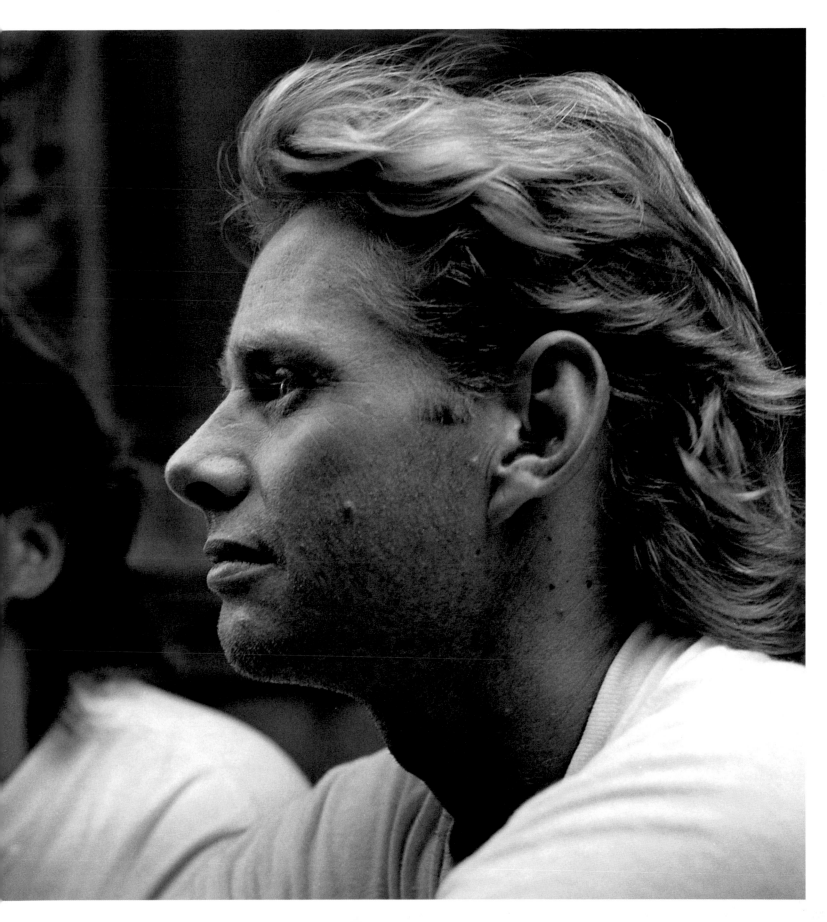

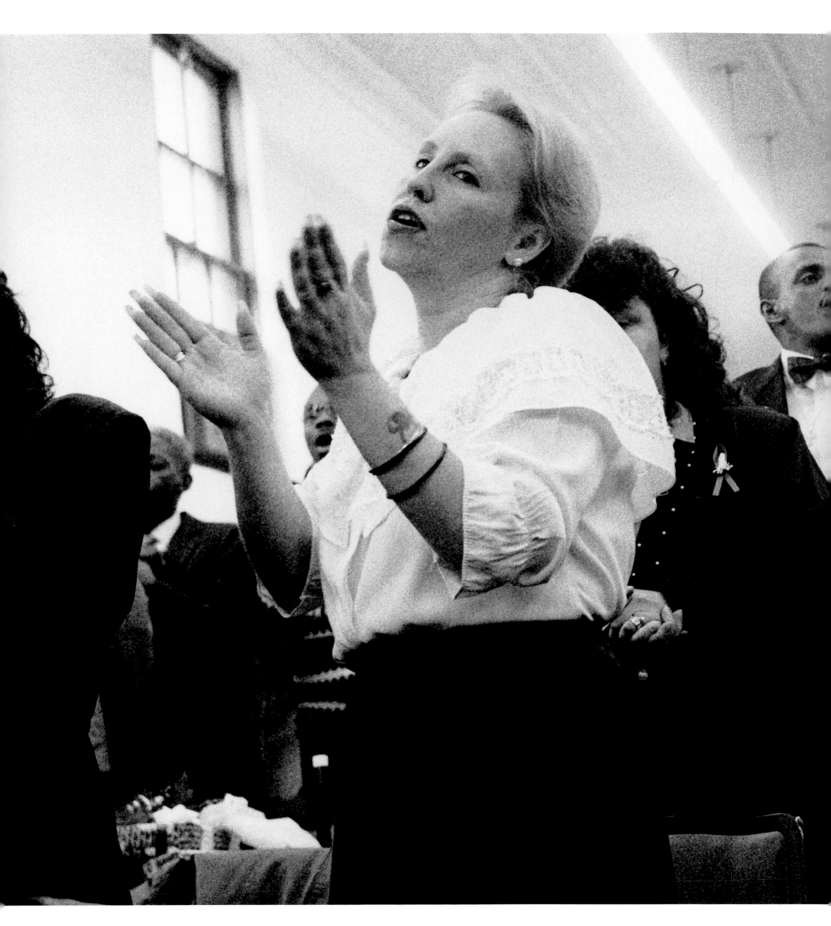

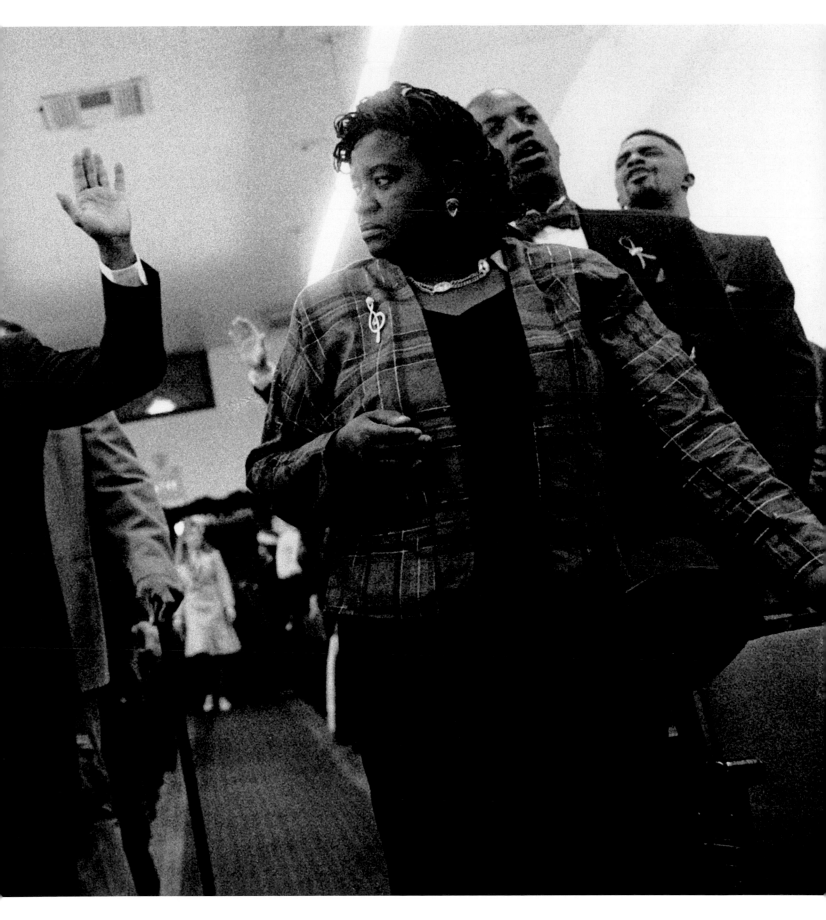

Lisa Dow Katz
Rego Park, New York, November 5, 1987

Lisa fell in love, got married and was planning to start a family
when she was diagnosed with AIDS. When we met she was
volunteering with ADAPT, an outreach program for addicts, talking
to IV drug users about HIV transmission and prevention.

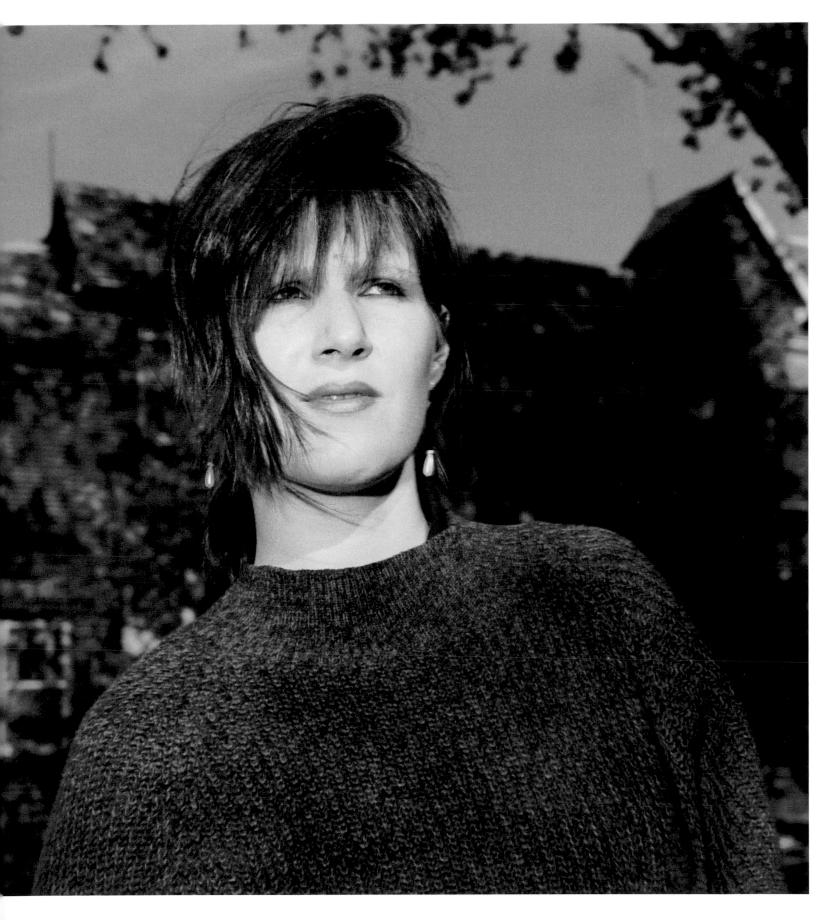

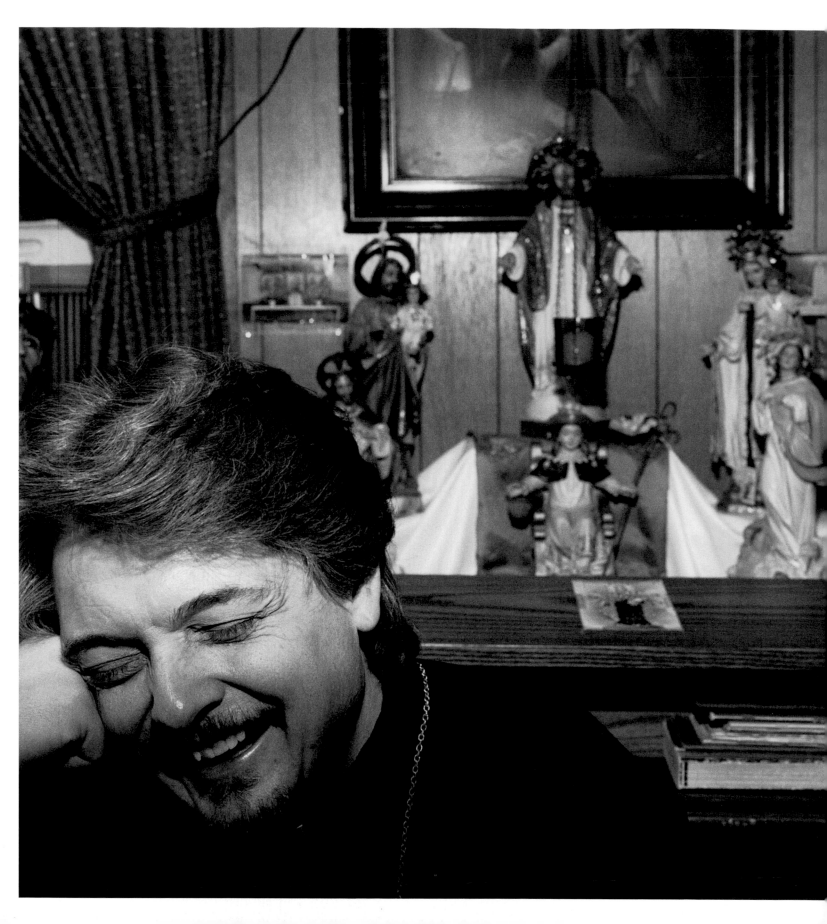

Jeff Cates

Brooklyn, New York, November 10, 1990

When I first met Jeff he was wearing red cowboy boots, a motorcycle jacket and a priest's collar. A former Catholic priest, Jeff left the priesthood to pursue pastoral counseling and political activism.

Jeff died on December 13, 1991.

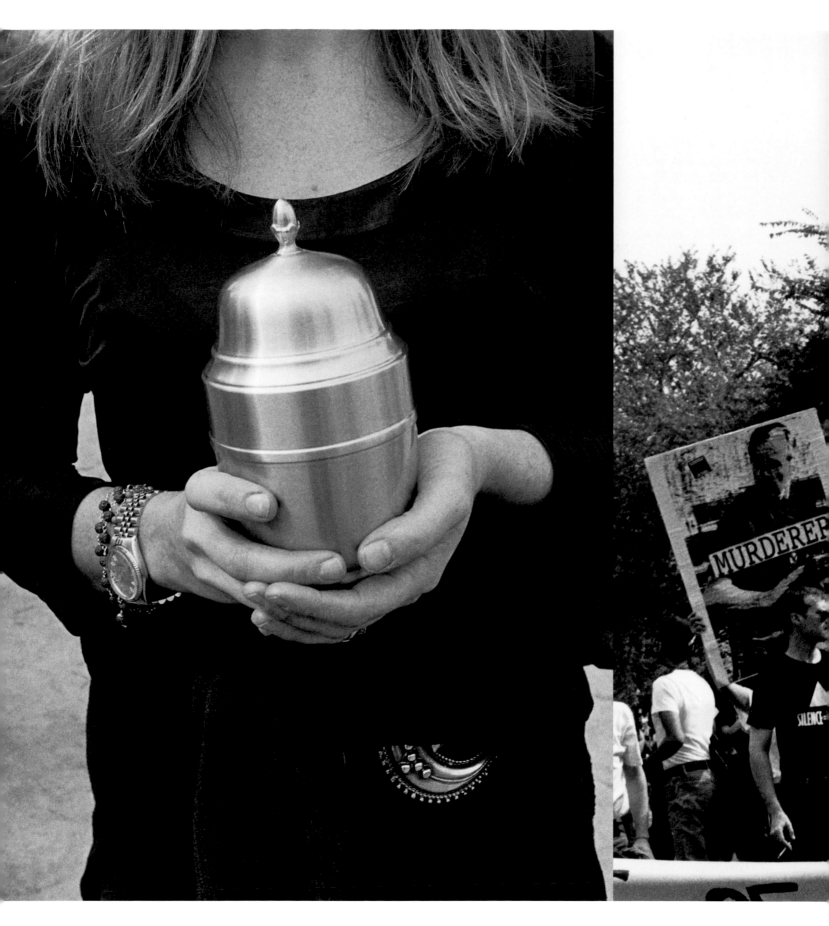

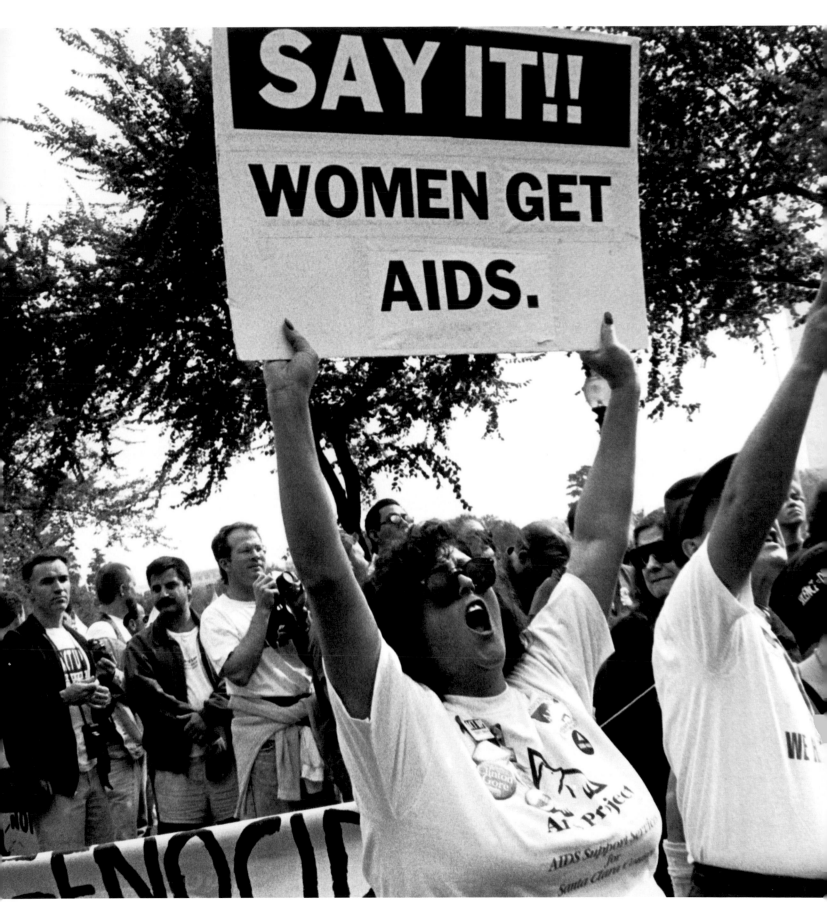

John Campanella
New York City, October 21, 1987

I only met John twice. When I went to his apartment to photograph him
I was a bit surprised by his formality — he wore a jacket and tie.
He seemed very shy, reluctant to speak, but at the same time quite
confident about the way he presented himself to the camera.

John leapt from an uptown roof in 1988.

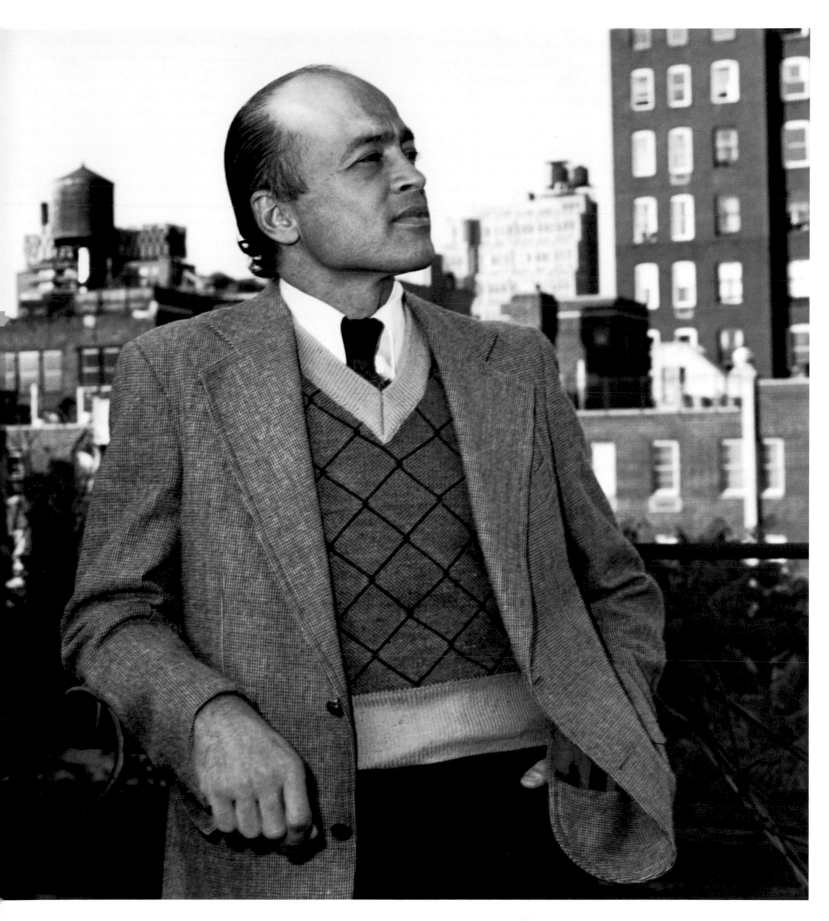

Leon Washington
New York City, December 31, 1987

Leon was a staff member of Gay Men's Health Crisis, known and
loved for his culinary skills and devotion to other people with AIDS.

Leon died in April, 1991.

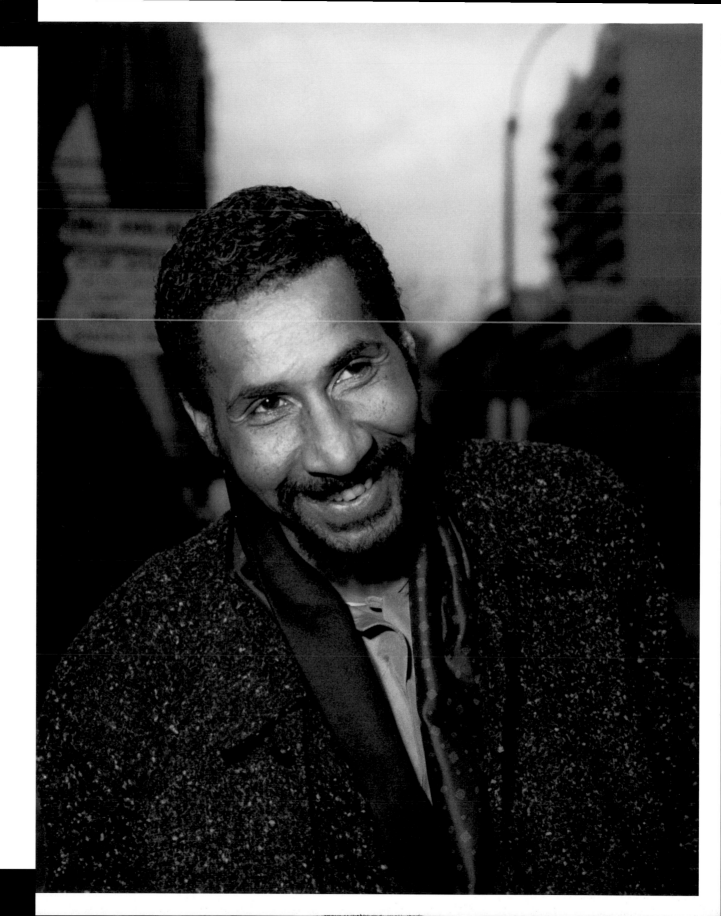

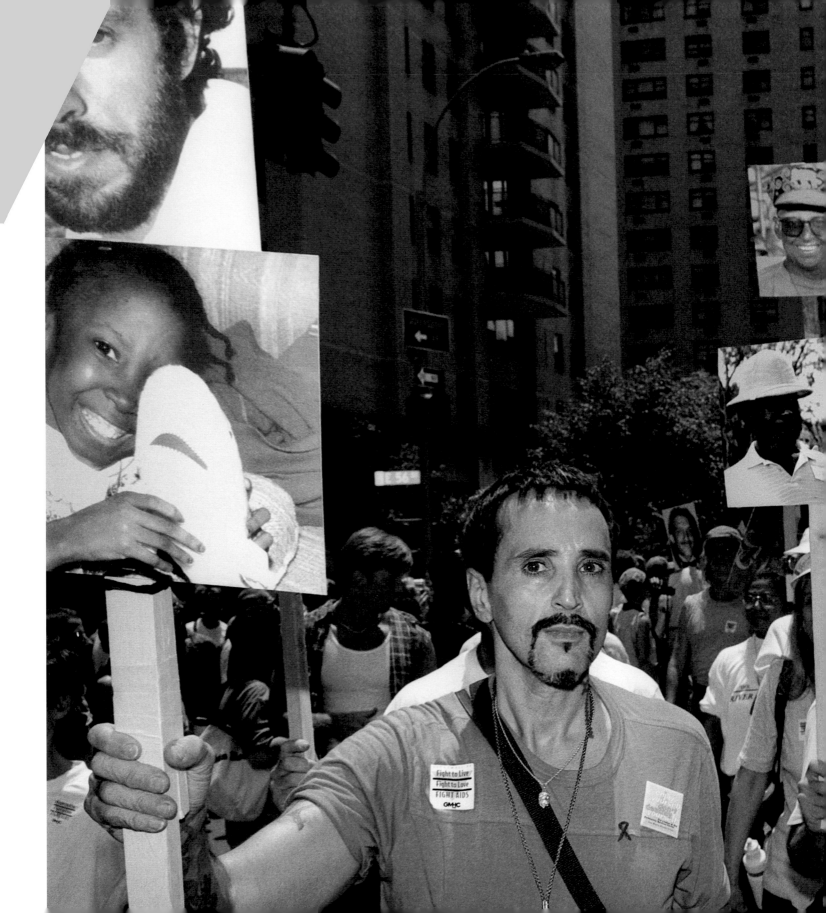

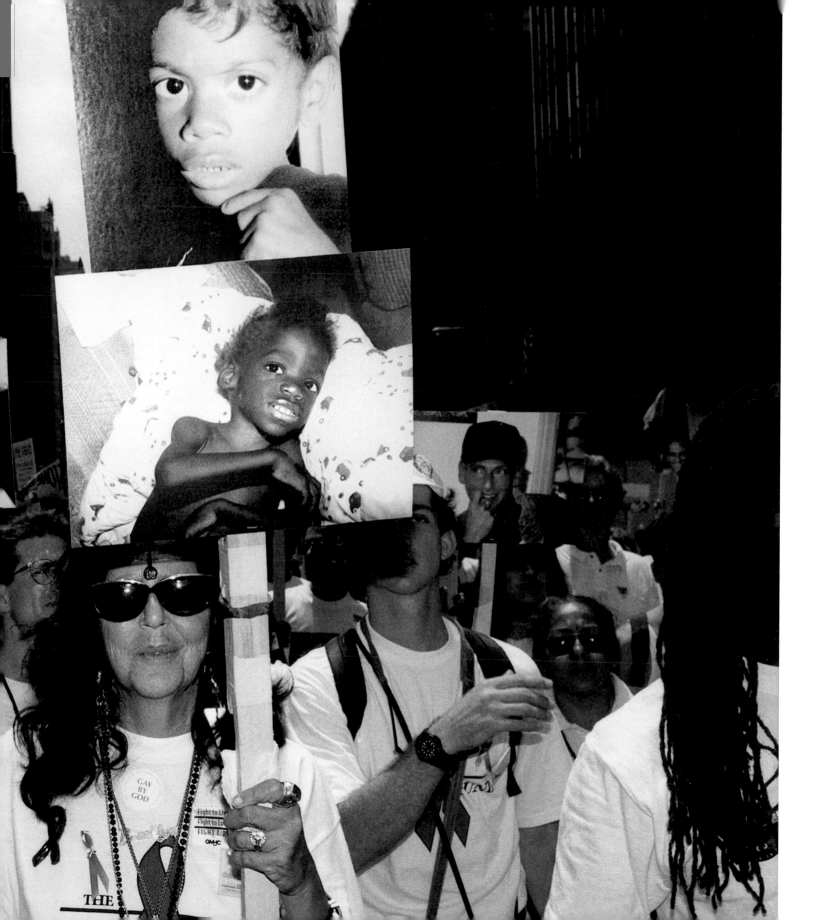

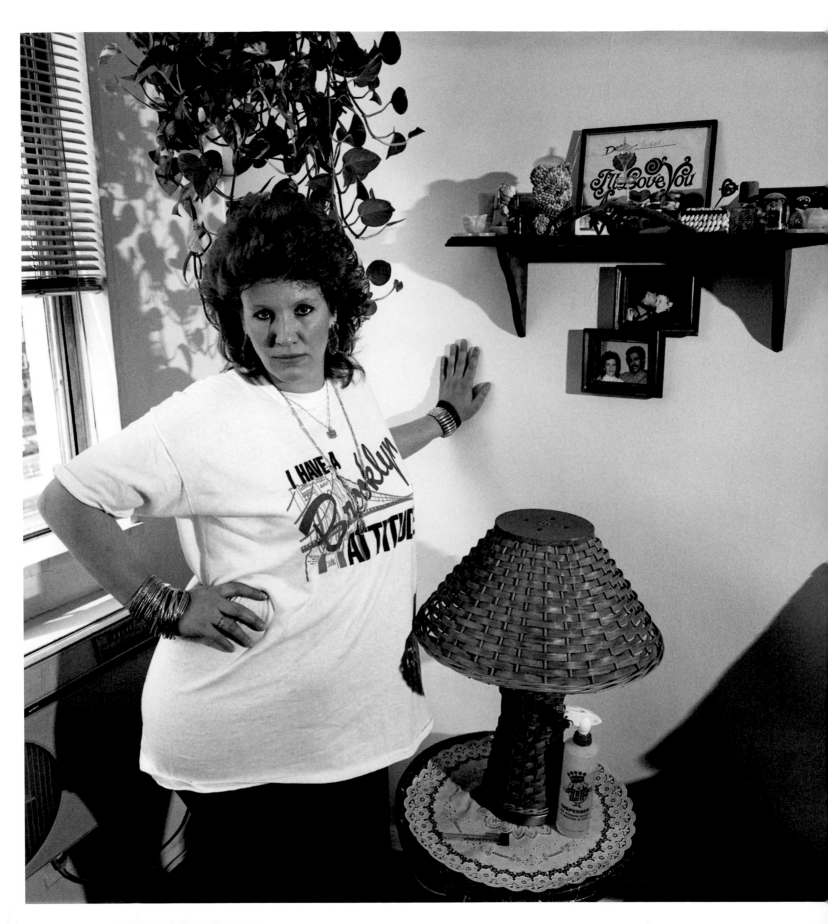

Leslie King-Levy
Brooklyn, New York, April 2, 1991

"Six years ago I received an HIV+ diagnosis within the confines of prison walls.
I could tell no one, I couldn't share this information with the jailhouse mentality.
I was uncertain about what I felt until I hit the streets and it was then that I
became devastated watching friends and relatives die around me. I was terrified
of degenerating physically and mentally.... I was also a victim of ignorance,
suffering the stigma of being a junkie, fag or freak. To the people who say
'they did it to themselves' I have a message — why don't you educate yourself and
your children? It could be you, especially when you don't practice safe sex."

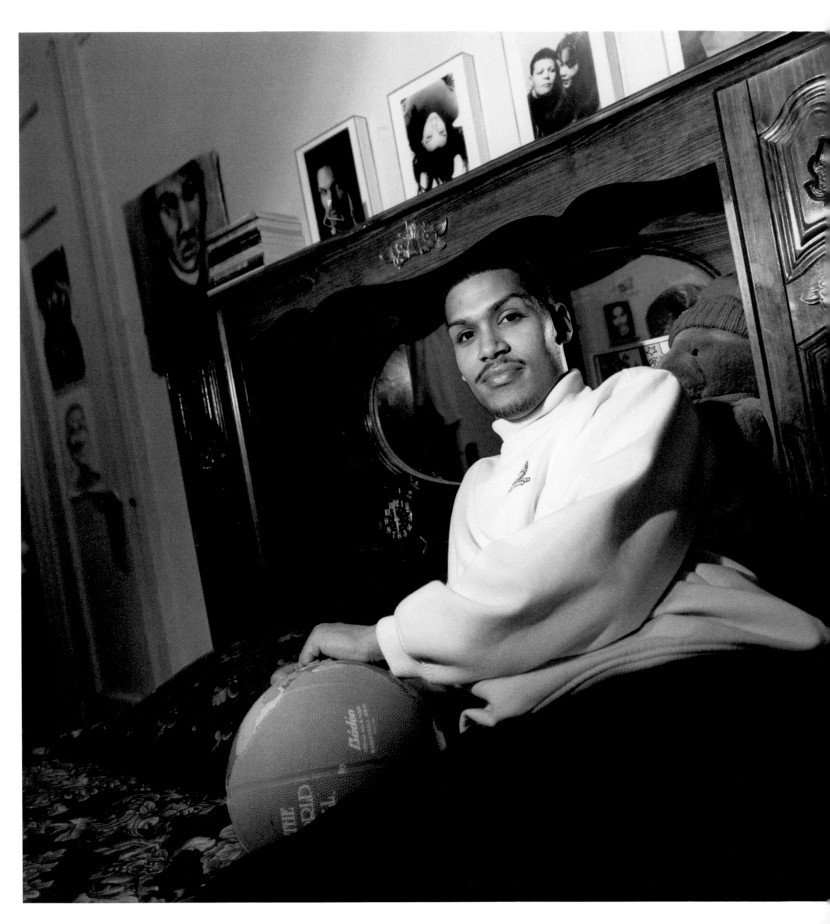

Luna Ortiz
Bronx, New York, January 5, 1995

Luna is twenty-two years old and has been HIV+ since he was fourteen.
He is a talented painter and photographer and works as a peer counselor
for young people with AIDS at *Stand-Up Harlem* in New York City.

Manny Vasquez
Brooklyn, New York, 1993

A handsome aspiring boxer known around the discos, Manny was
a photographic subject for Peter Hujar in the 1970's. When I photographed
him he was the subject of a newspaper article on being a prisoner with AIDS.

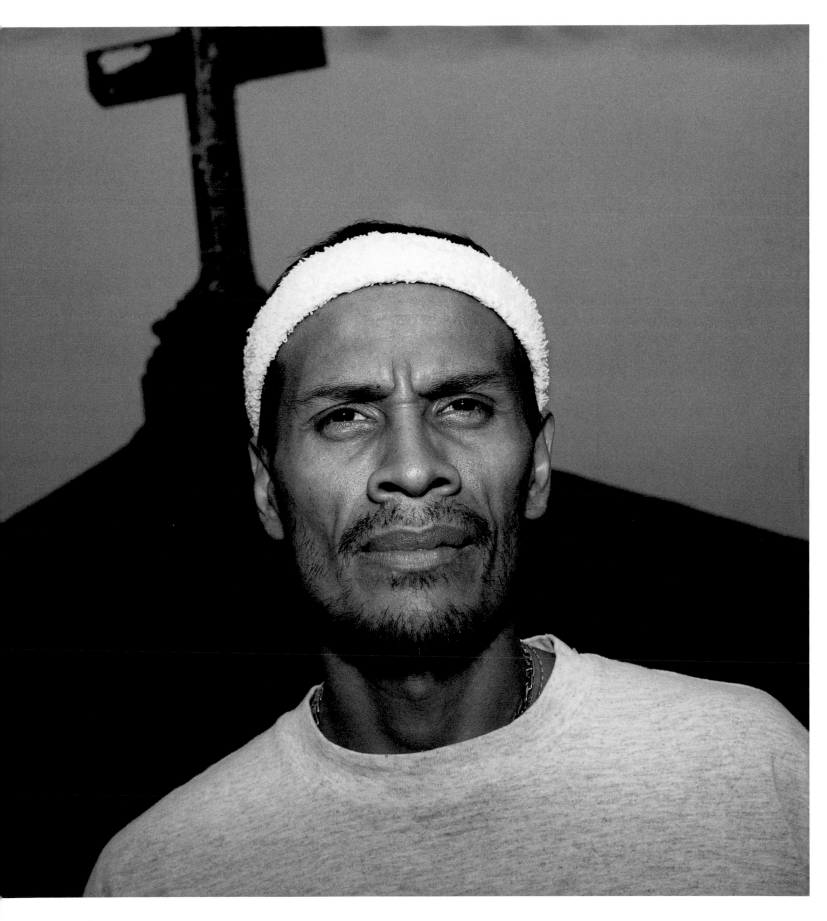

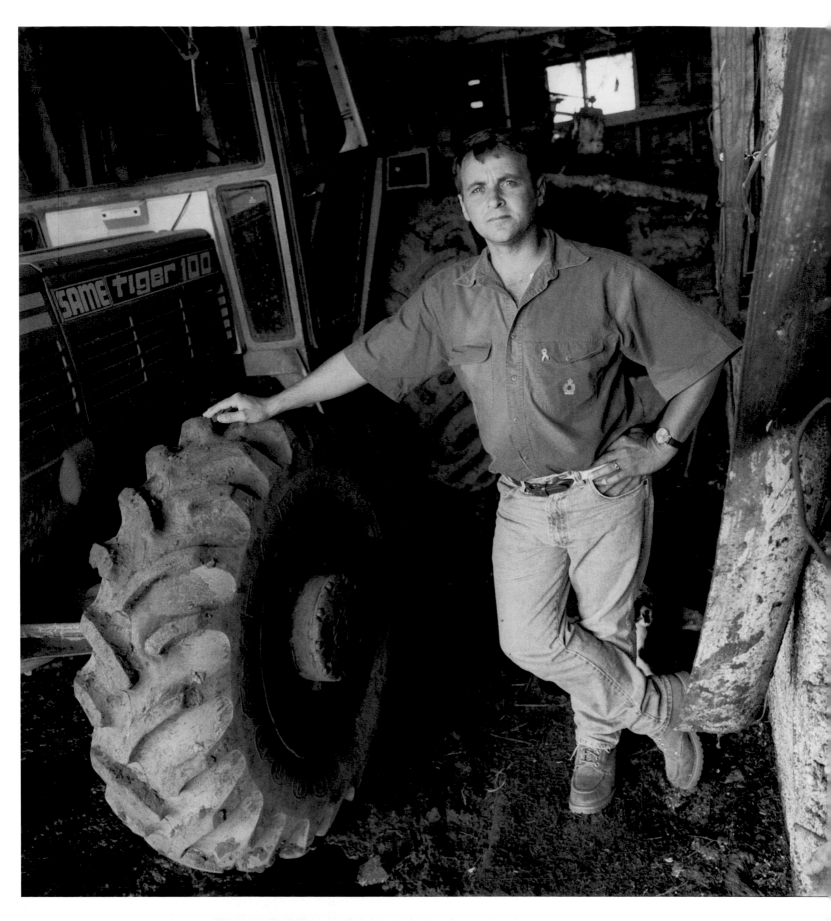

Mike St. Hilaire

North Bangor, New York, August 8, 1995

Mike, 37, lives and works on his family dairy farm near the Canadian
border. He is on the local school board, and works with troubled youths,
and is the only person in town who has AIDS. He also travels around
New York State speaking about his experiences of living with the disease.

Anthony and Donna Martinez with daughter Chrissy
Brooklyn, New York, 1994

Donna and Anthony discovered that they had AIDS after their
four-month-old daughter, Margaret, was diagnosed. This happened
while Donna was pregnant with her seventh child. Fortunately,
all of the other children are HIV– negative, but Margaret died in
February, 1993, at the age of 22 months.

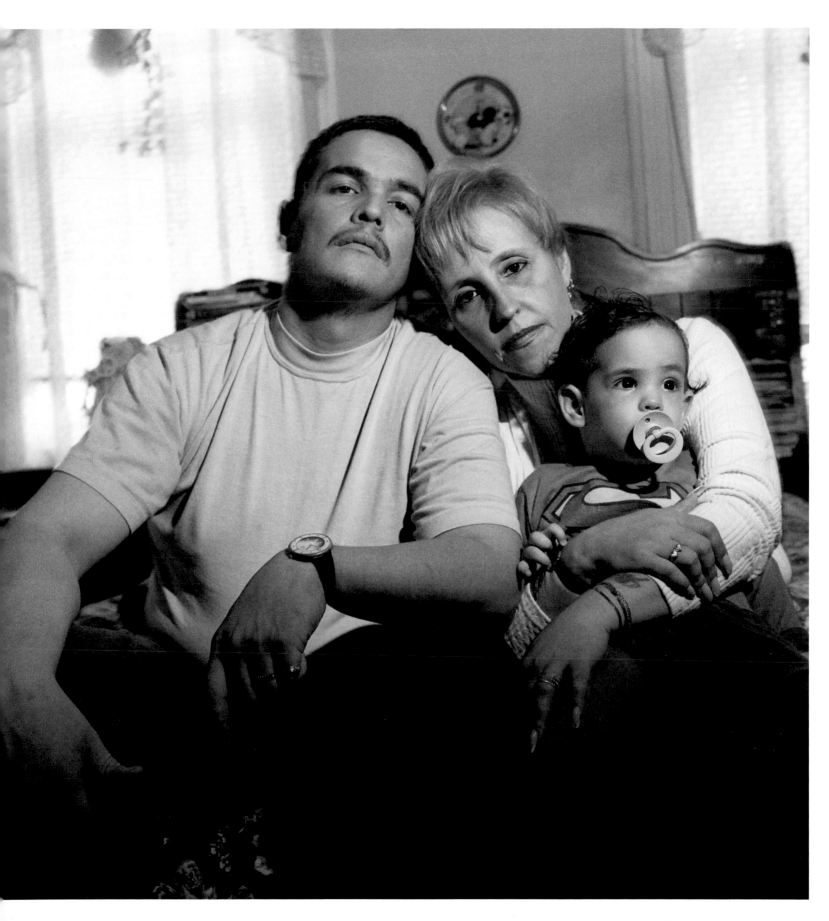

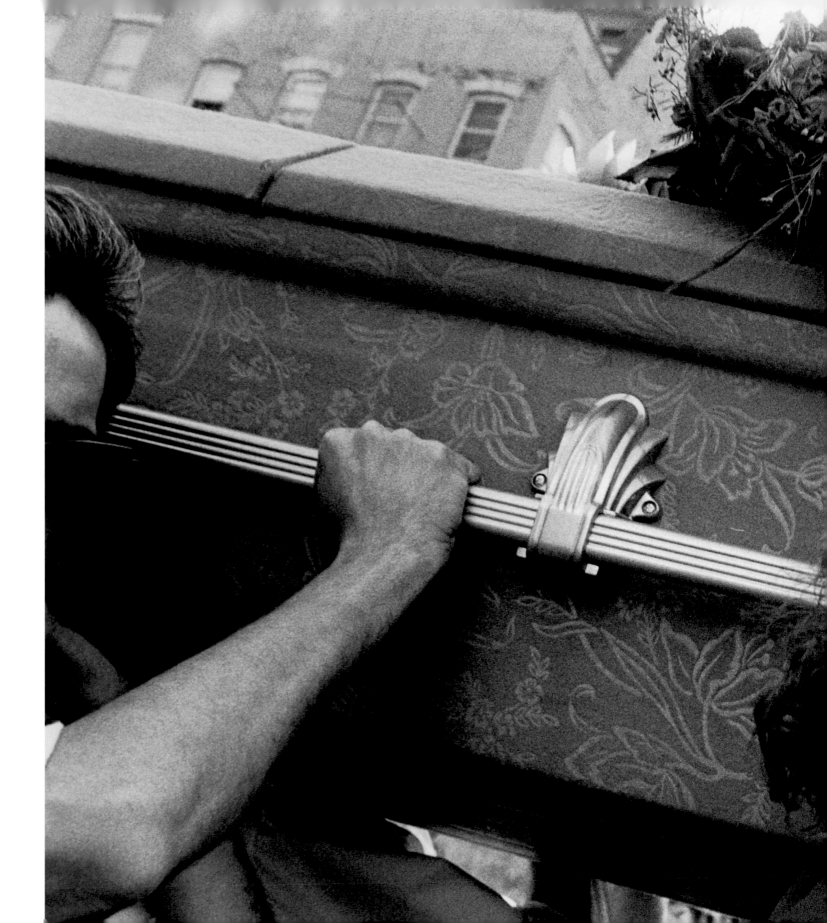

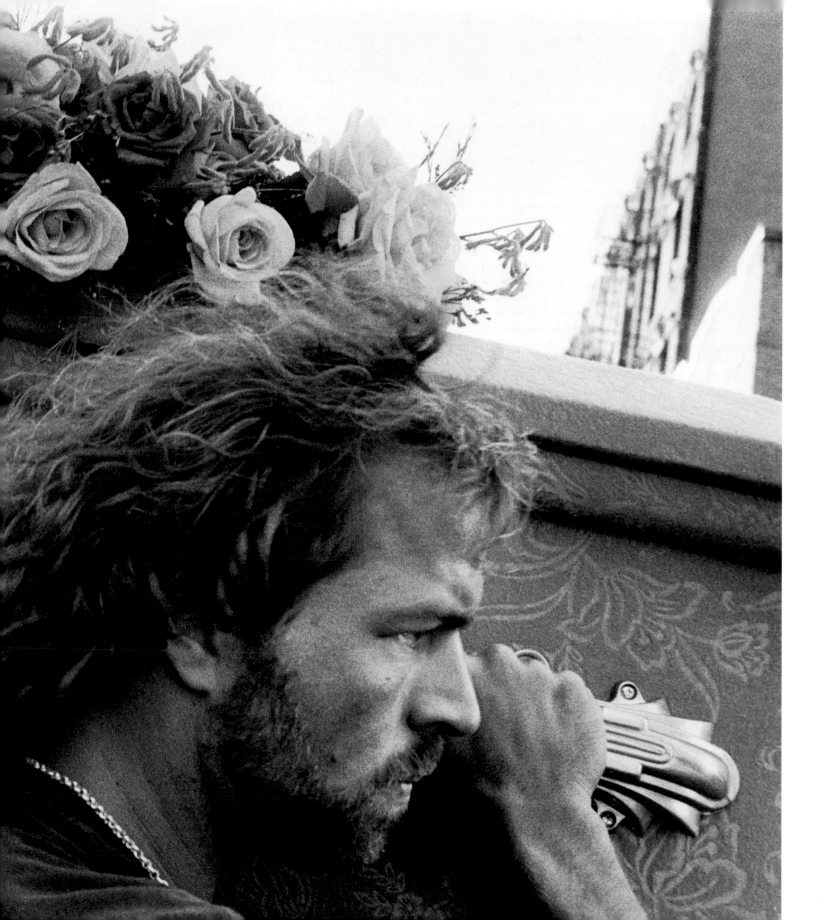

Michael Fender and partner David
New York City, February 5, 1988

Michael died on September 26, 1988.

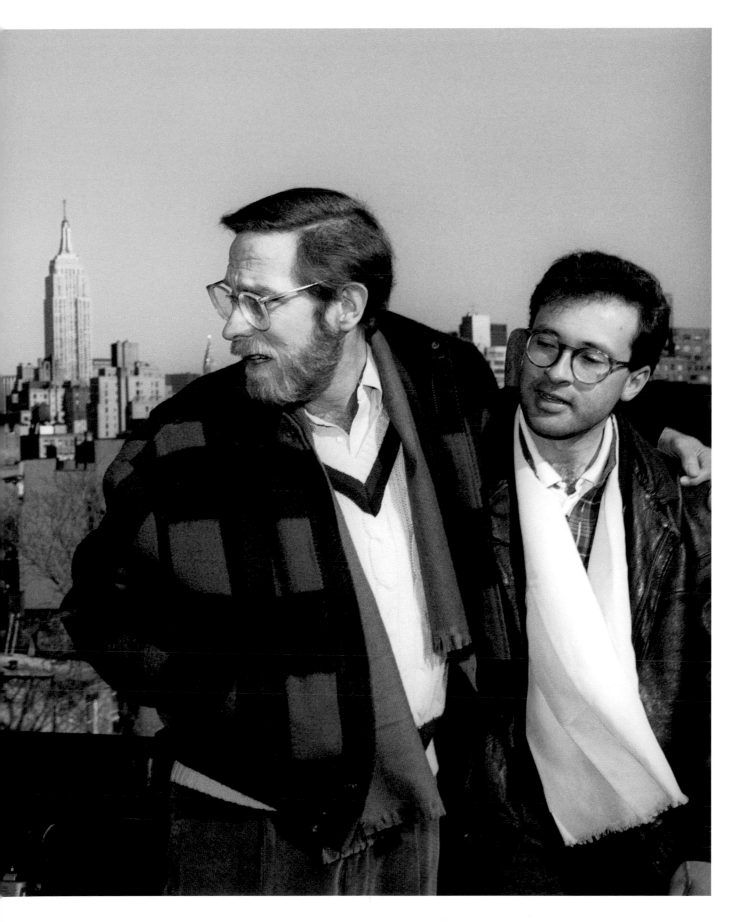

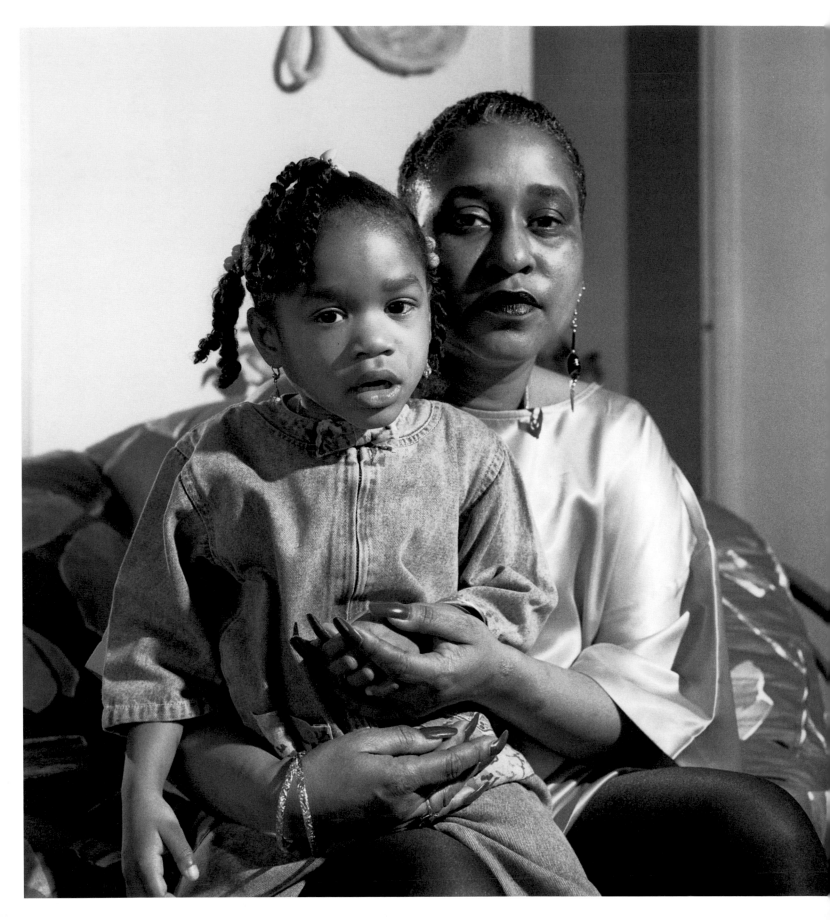

Phyllis Sharpe and daughter Siouxchie
Bronx, New York, February 11, 1991

Phyllis said: "...and a month later she called me and told me
and I like lost my mind 'cause when you're first diagnosed you think
you're gonna die. Since then, and I know this sounds weird but
I say it all the time, I've never lived this well in my life...finding out
I was (HIV) positive seemed to be the best thing to happen to me.
I live a normal life—maybe more normal than someone who isn't."

Michael O'Brien
Troy, New York, June 18, 1996

Michael, 35, was a junior high school teacher and caterer in
Los Angeles when diagnosed with AIDS in 1994. He was fired
from his catering job due to his illness and won a small
discrimination suit against the employer. He moved back to Troy,
New York, to be with his family which had been suffering from
the deaths of his father and grandmother (not HIV related).

About having AIDS Michael said:
**"When you have this you lose everything. I lost my home, my job,
my friends, my money...everything I worked for over ten years."**

Michael became involved in drug trials with protease inhibitors
and shortly after I photographed him, HIV was undetectable in his body.

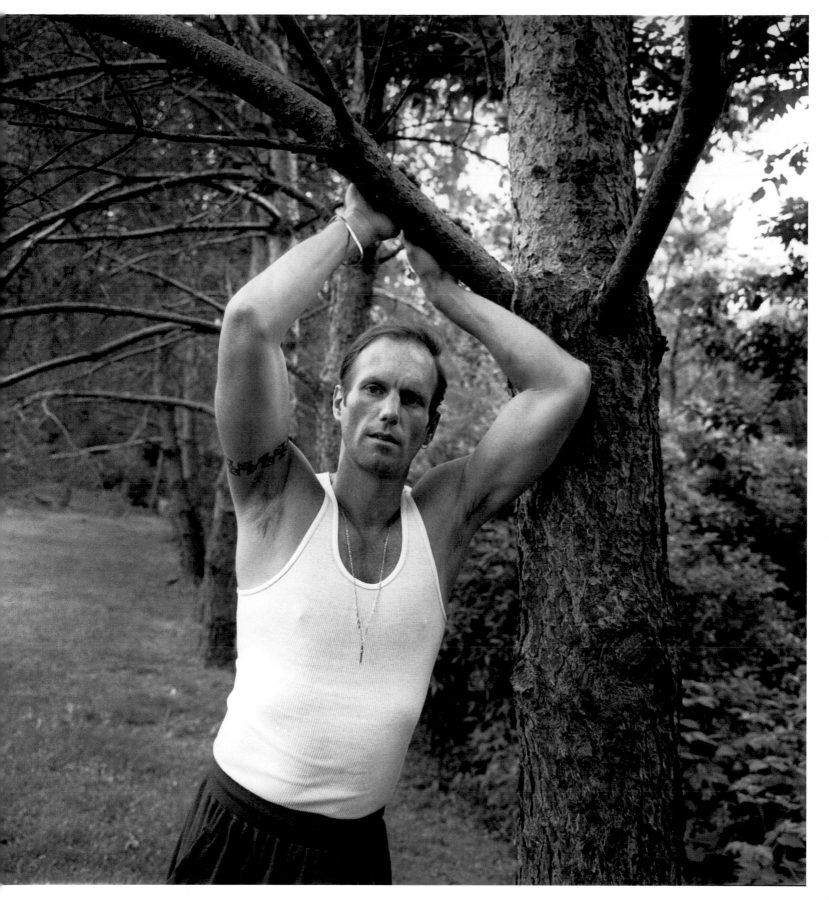

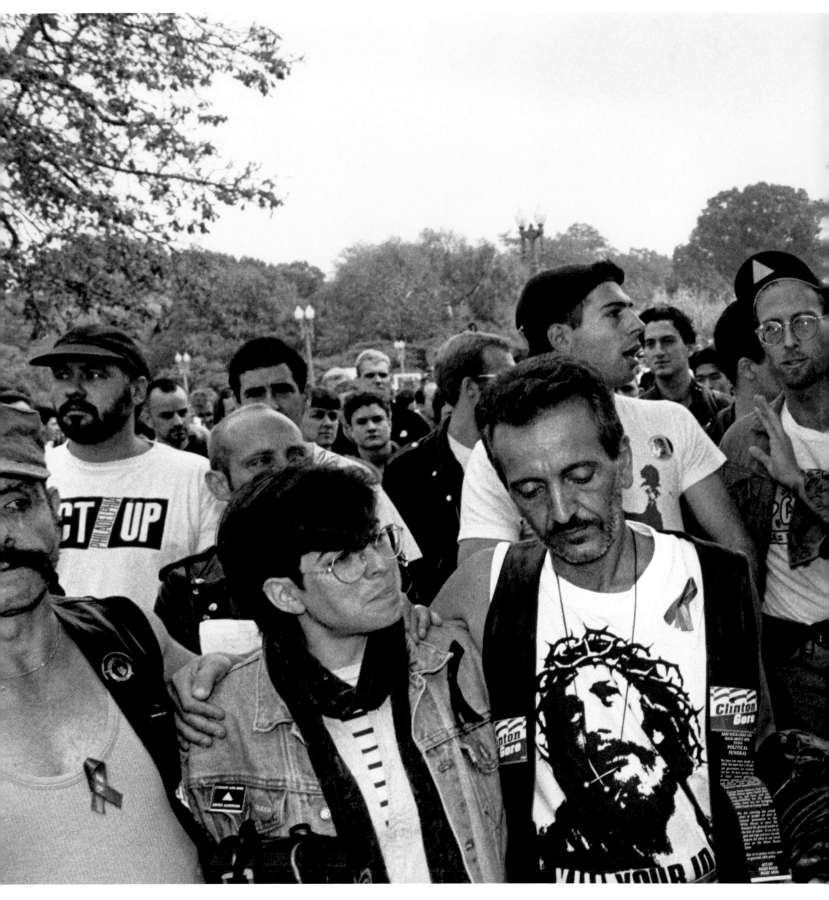

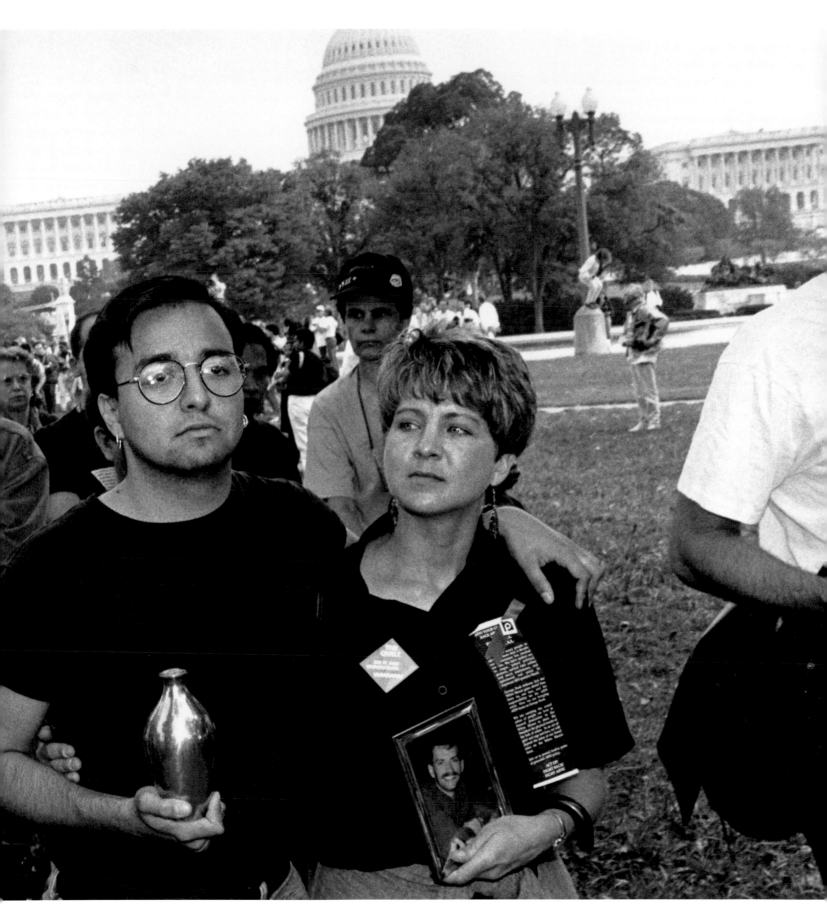

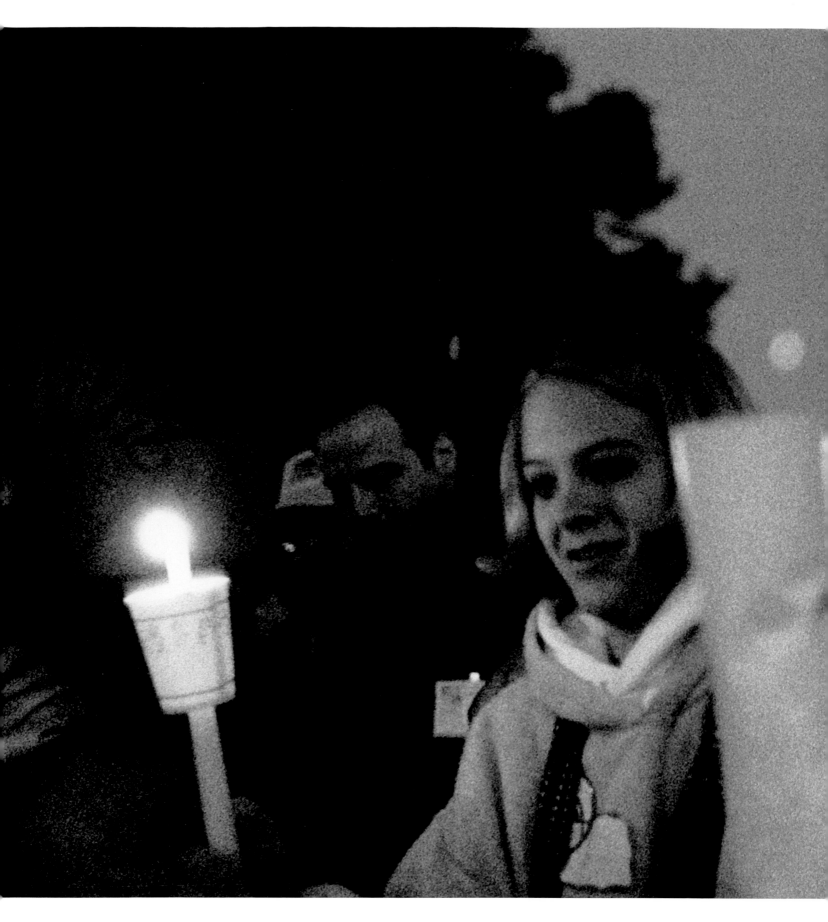

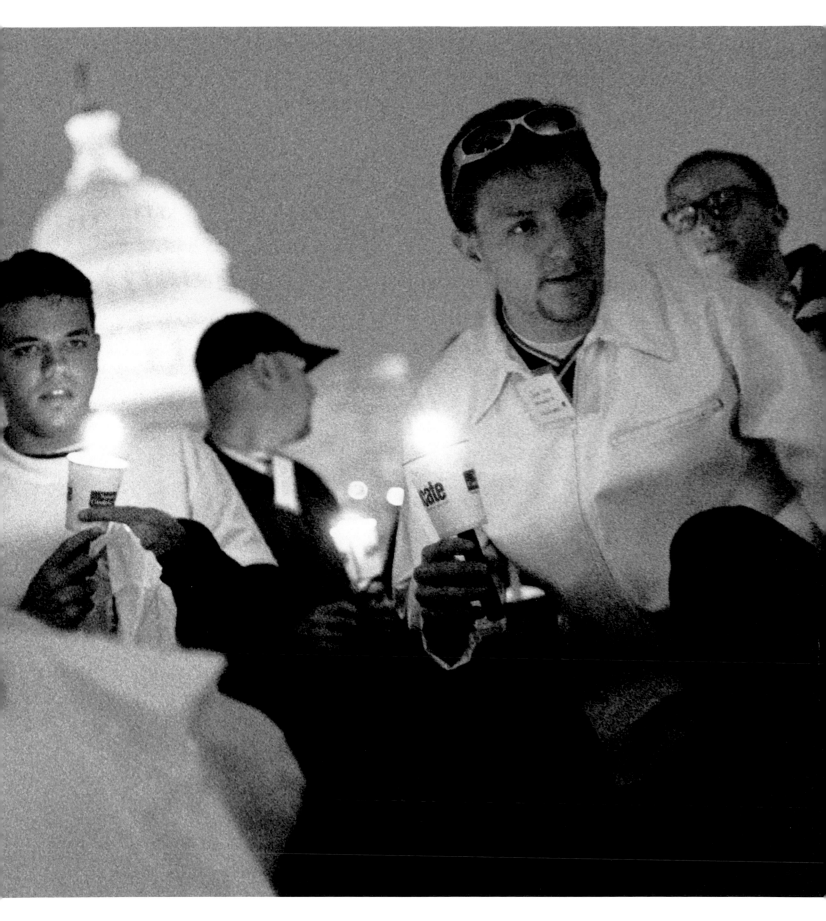

Michael Angerola
New York City, October 7, 1987

Michael was the first person with AIDS that I photographed.
He had cared for two lovers, both of whom died from AIDS,
and though ill himself, maintained the strength to volunteer
with Gay Men's Health Crisis. In addition, he went under-cover
to expose fraudulent "miracle cures" for AIDS.

Michael was being cared for by a new lover when he died
on August 5, 1989.

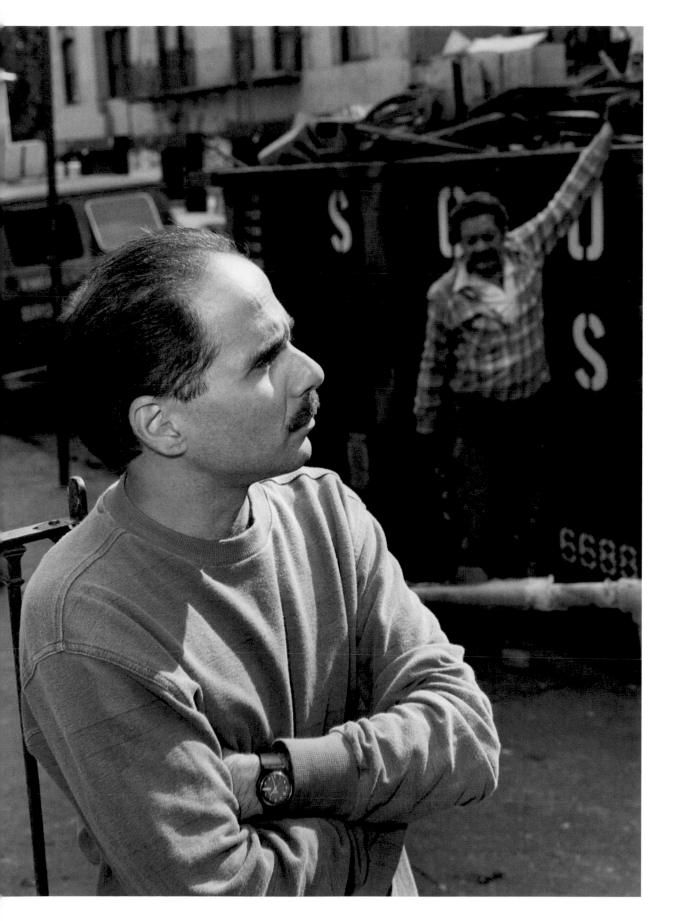

Megan Fox

Washington, D.C., February 7, 1995

Megan is nine-years-old and lives in St. Michaels, Maryland.
Her mother, Carol, contracted the virus from a blood transfusion
in 1982 and passed it along to Megan. Megan travels around
the country with her father, Jay, sharing their experiences of living
with HIV/AIDS. Carol died on Christmas day, 1991.

Megan is shown here after speaking to a group of high school
students about living with AIDS.

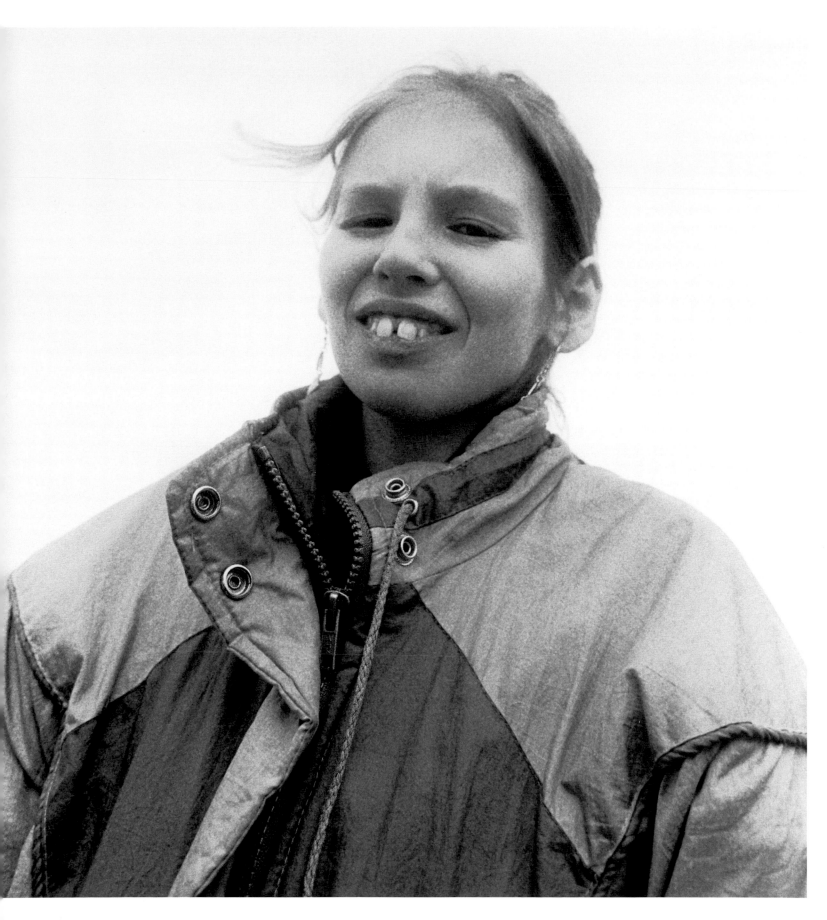

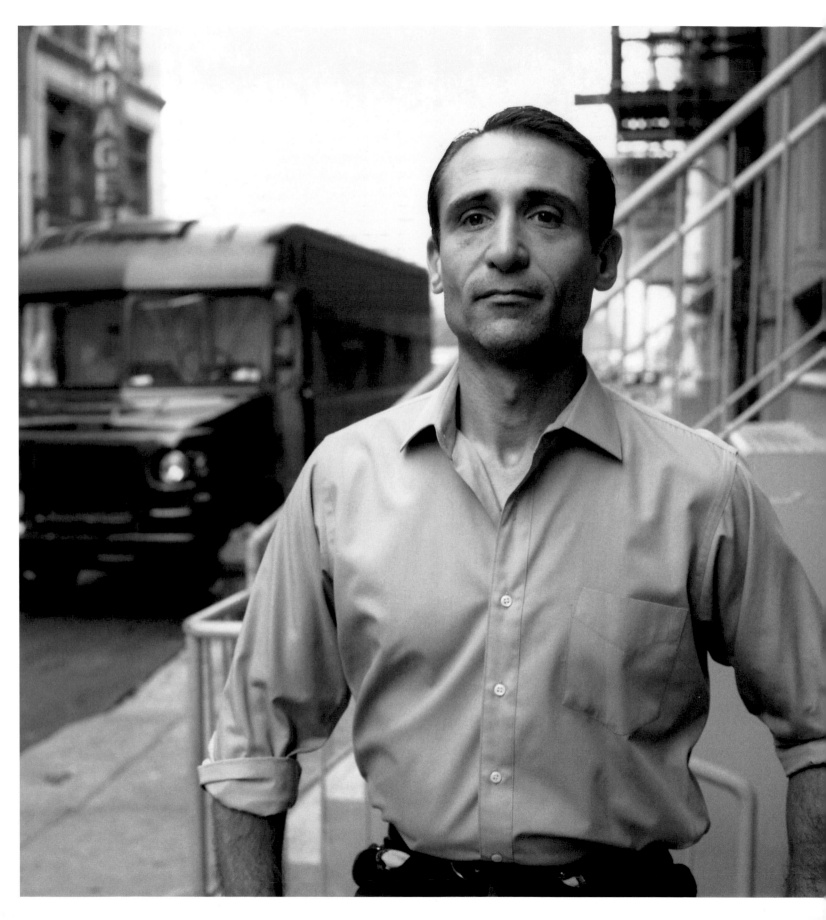

Michael Schwartz
New York City, December 4, 1991

Michael, 44, a former dancer, became a video photographer
and founded *Character Generators*, an important archive of dance
and theatre performances.

Michael died on May 17, 1994.

Kristy Fernandez and her father Carney
Brooklyn, New York, January 16, 1993

Kristy became ill after her mother was murdered and soon after was
diagnosed with AIDS. Carney has since quit his job to care for Kristy
full-time and wants to volunteer to educate others in his neighborhood
about the disease.

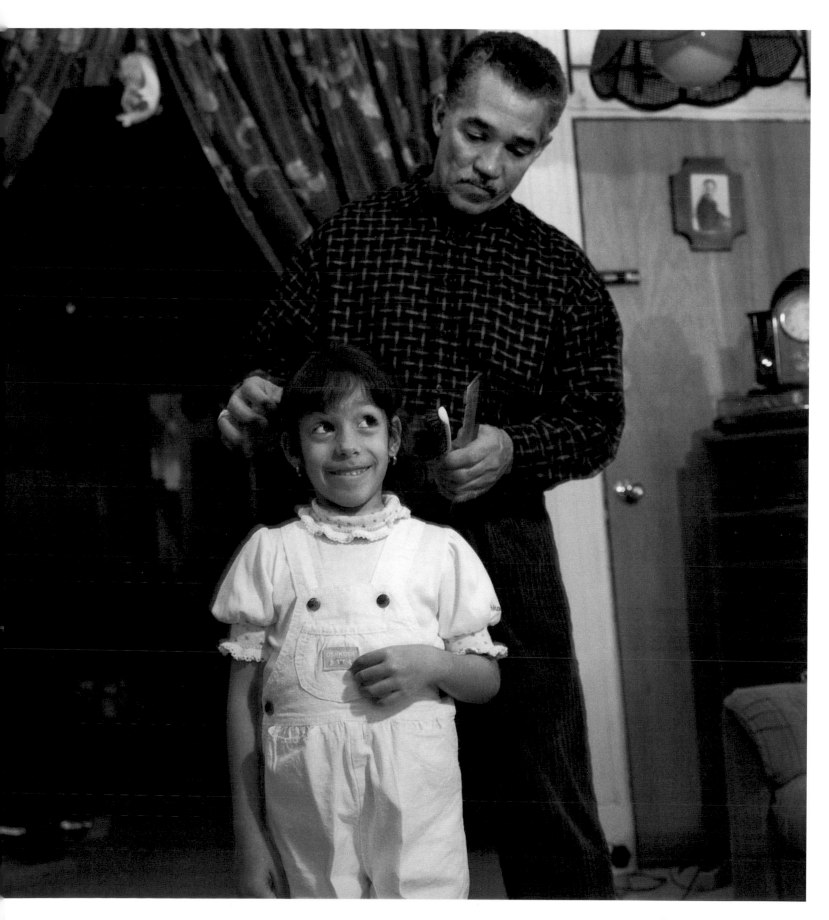

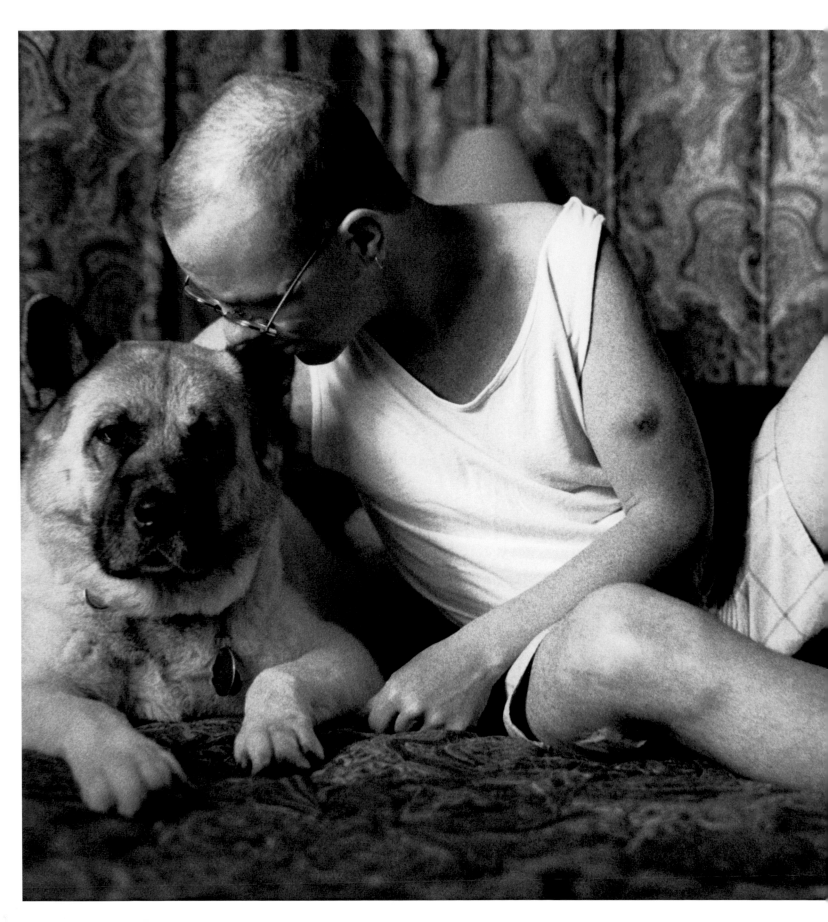

Razor Sharp
New York City, July 12, 1991

"I don't use my real name, I go by Cutter or Razor Sharp. It's really
an accurate name for me because I made my position in the gay
community by speaking the truth—if someone's really being an asshole,
I'll call them an asshole. I found out about my HIV status a little
over two years ago and it's been a really interesting process—learning
about HIV, monitoring my blood and having to face AZT—it's been
a constant push to better myself. It's not about being sick, it's about
getting well and it's a process that took me 30 years to discover.
I've found myself a new doctor who can better work with how I need to
take care of myself…and I'm learning for myself what I need to do."

Razor died on September 25, 1993.

Michael Joseph Millen
New York City, December 14, 1987

Michael died on September 2, 1989.

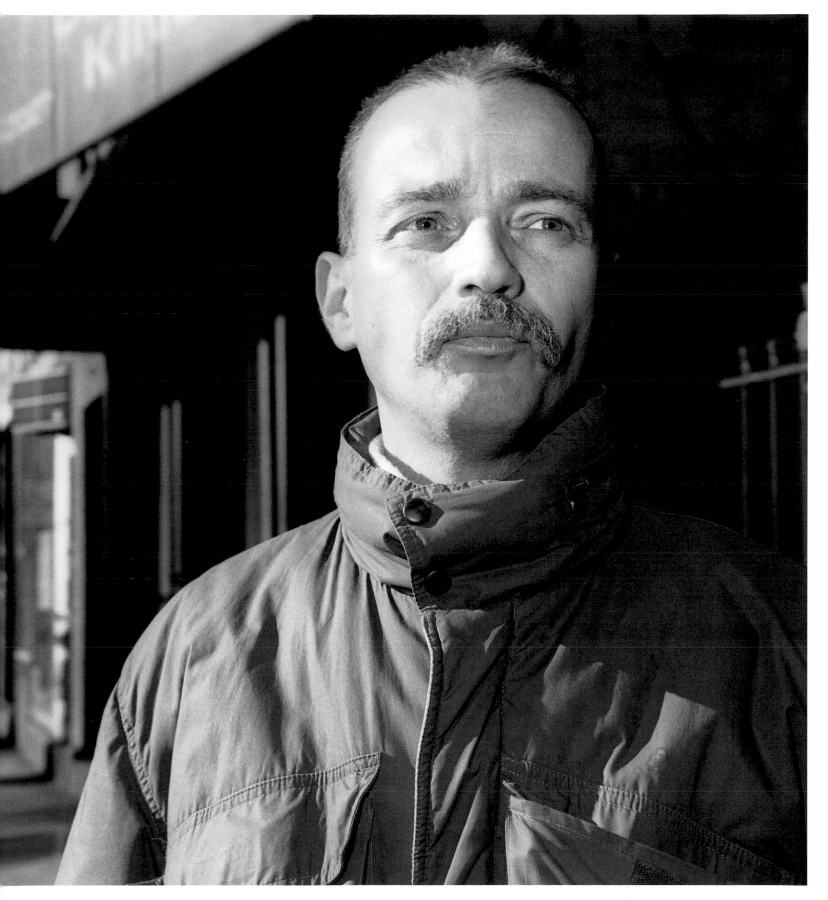

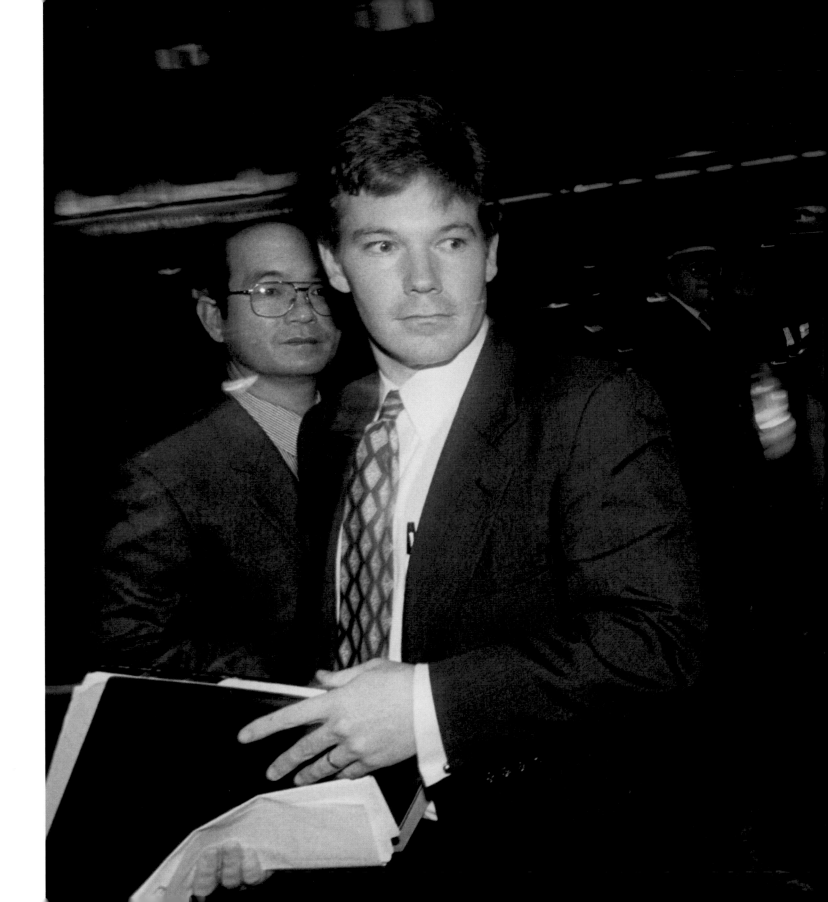

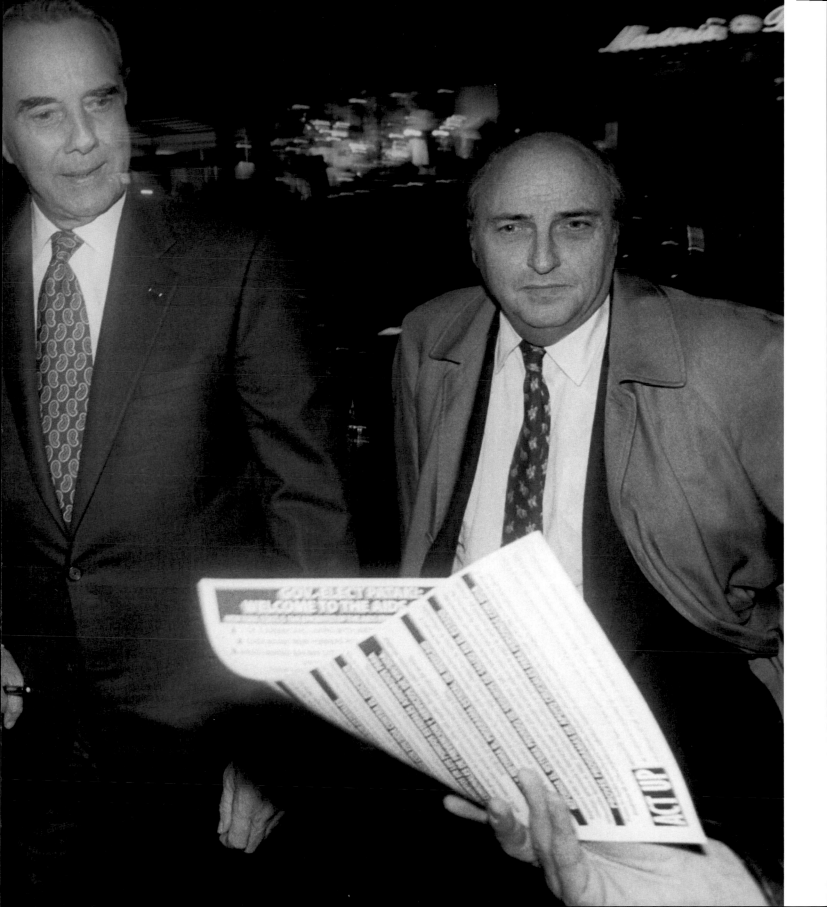

Susan Monahan
Saratoga Springs, New York, March 15, 1995

Susan was forced out of her beauty salon business after people
in the town where she worked learned that she was HIV+ and
that her husband had died from AIDS. She has since moved to
Saratoga Springs where she is an AIDS activist.

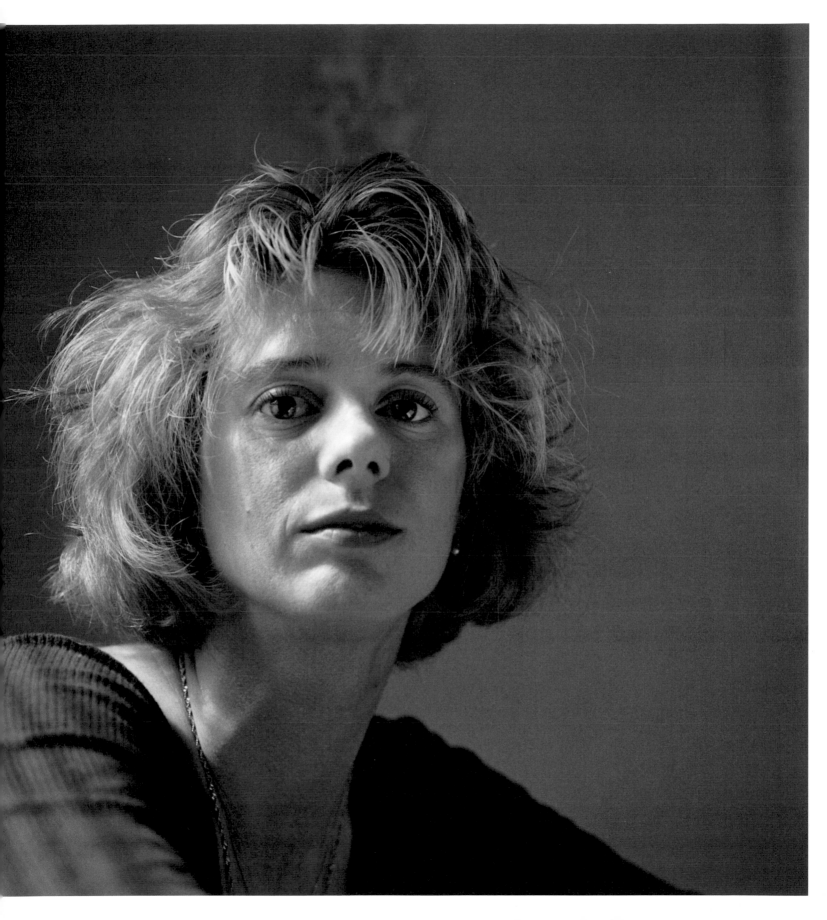

Wayne Trottie

Schenectady, New York, October 25, 1995

Wayne is 45 years old and has been HIV+ since at least 1987. He does public speaking about living with HIV and is on the board of The AIDS Council of Northeastern New York.

"I was homeless and wanted to change my life because I saw nothing in it but death. I saw friends die on the street and didn't want that for myself. One rainy night in an abandoned building I got on my knees and prayed, 'God, if you get me out of this I'll change my life' and three days later I was in detox and from there rehab, and I haven't turned around since."

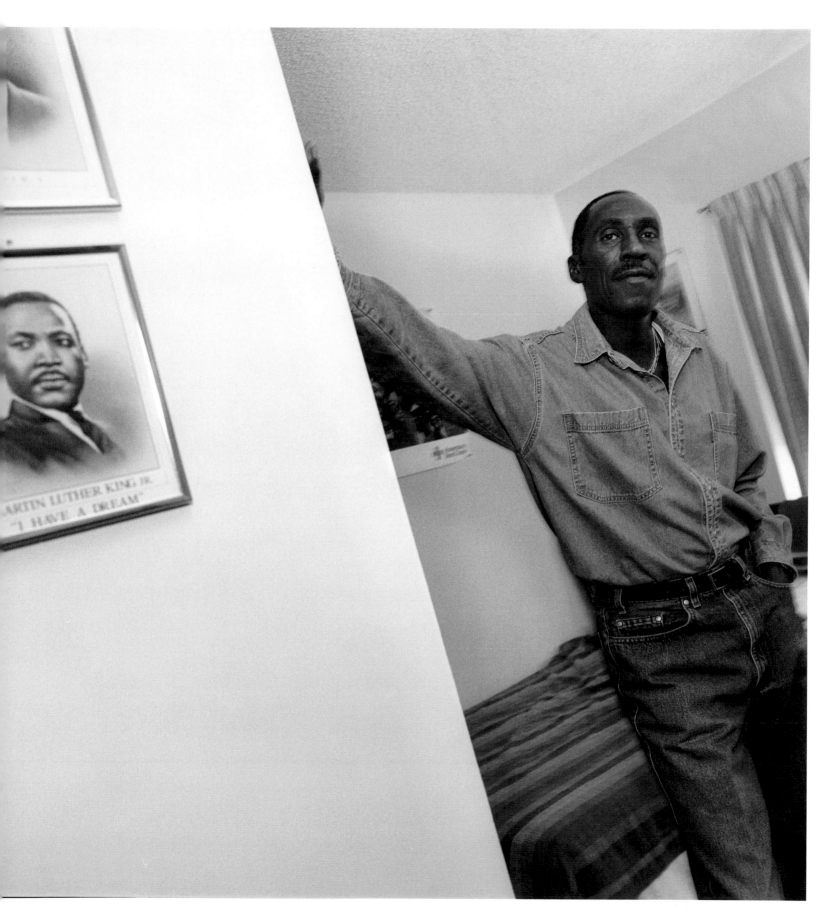

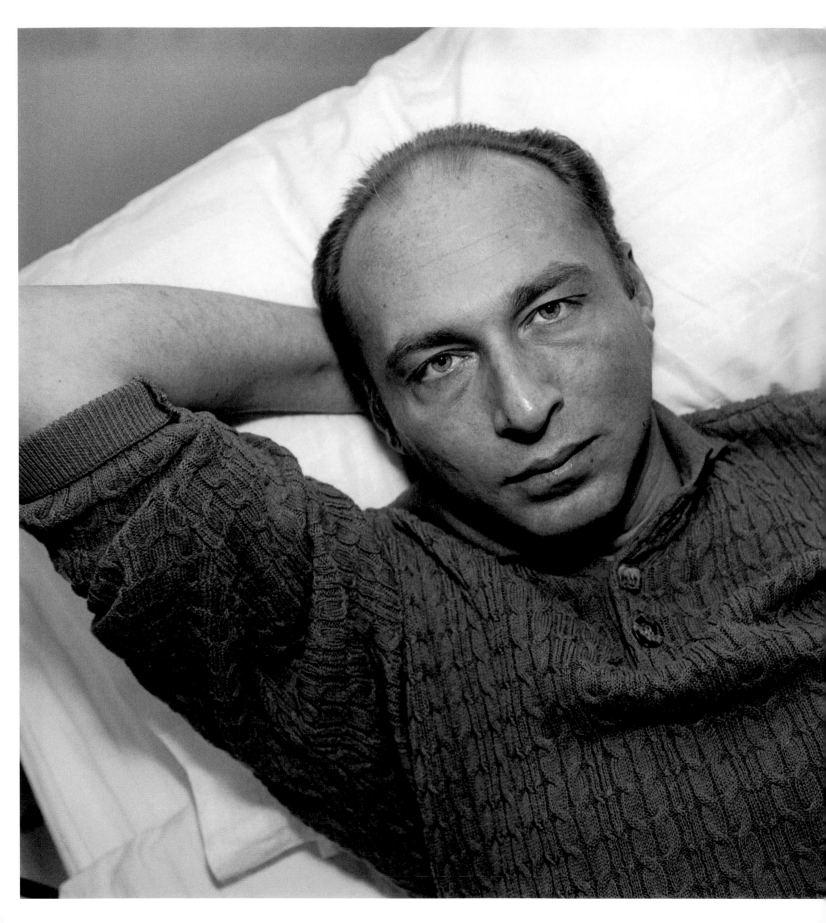

Ron Vawter
New York City, 1993

Ron, 44, was a member of the Wooster Group acting company
and won critical acclaim for his 1992 one-man Off Broadway show,
Roy Cohn / Jack Smith. He was also the first actor to acknowledge
his HIV status and continue working in Hollywood films. He appeared
in *Sex, Lies and Videotape*, *Silence of the Lambs* and *Philadelphia*.

Ron died on April 16, 1994.

Tim Gault and friend Dan
Brooklyn, New York, February 10, 1990

Recollections of Tim Gault, by Glen, John and Augusto:
"**Everything was planned out, every detail. I talked with him about his memorial and he was very clear. He wanted a Mexican-style Day of the Dead. We talked about that and there was no fear. One thing is that Tim maintained control over his life to the very end. That's how he left this world. One day he called and said, 'today is the day I'm going.' He wanted to say goodbye and to say that he loved me and to ask that I pray for him. Then the time came and he told his mother and sisters that they should go for a walk on the beach and a long-time friend stayed and helped him take the pills. By 10:30 he was in a coma and by 1 o'clock they realized that he stopped breathing.**"

Tim died on April 29, 1990.

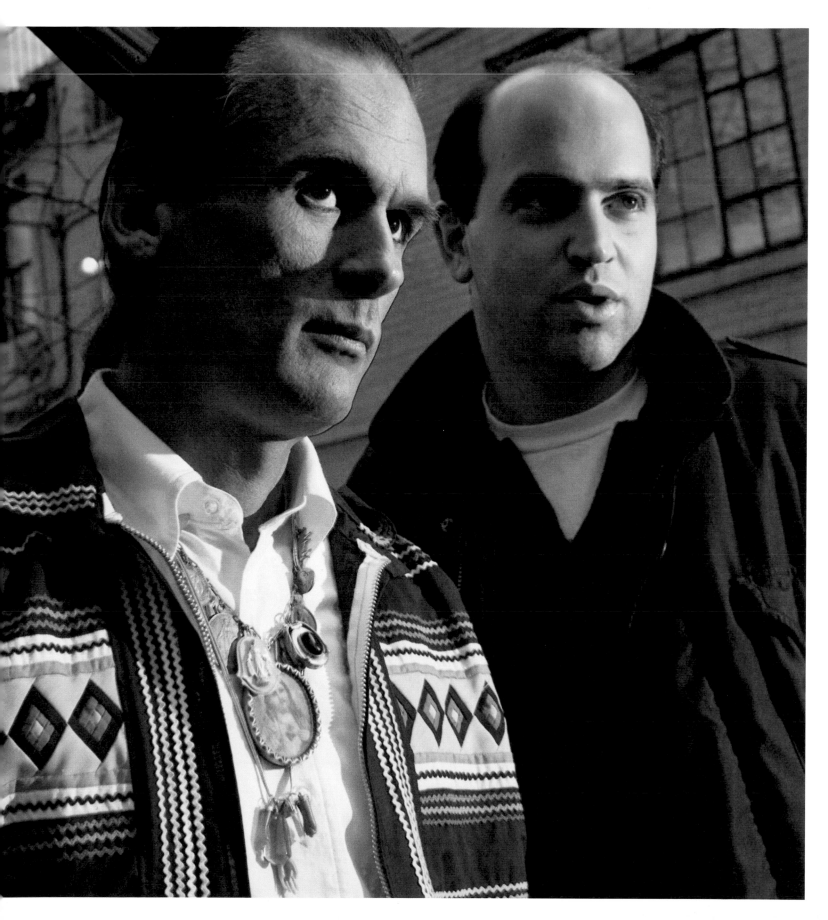

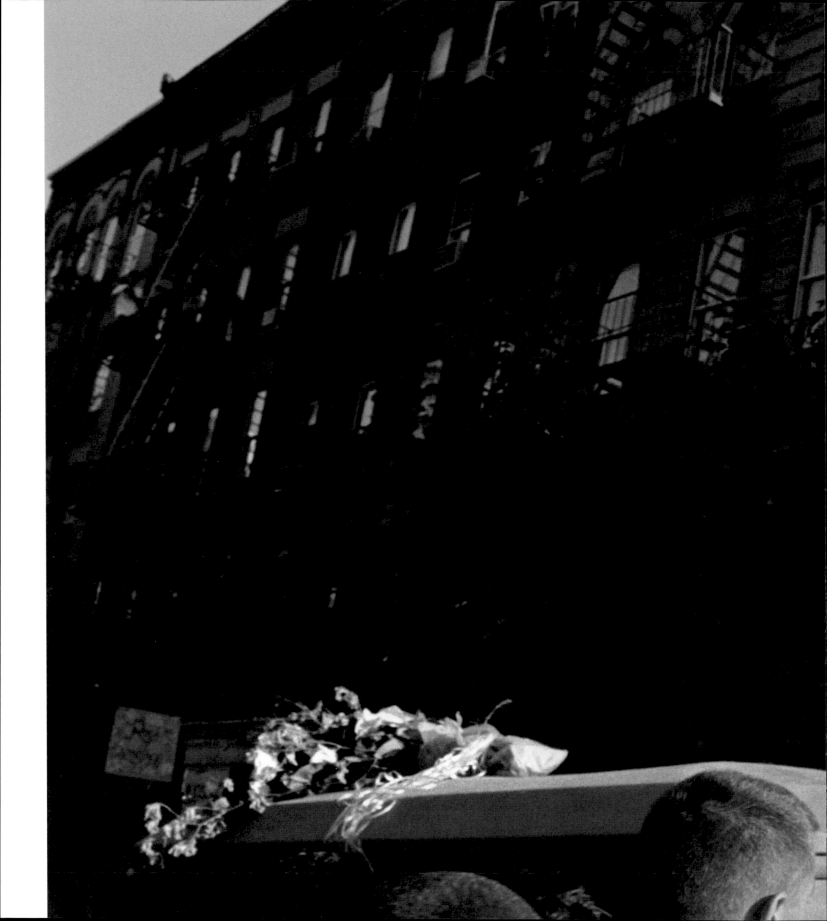

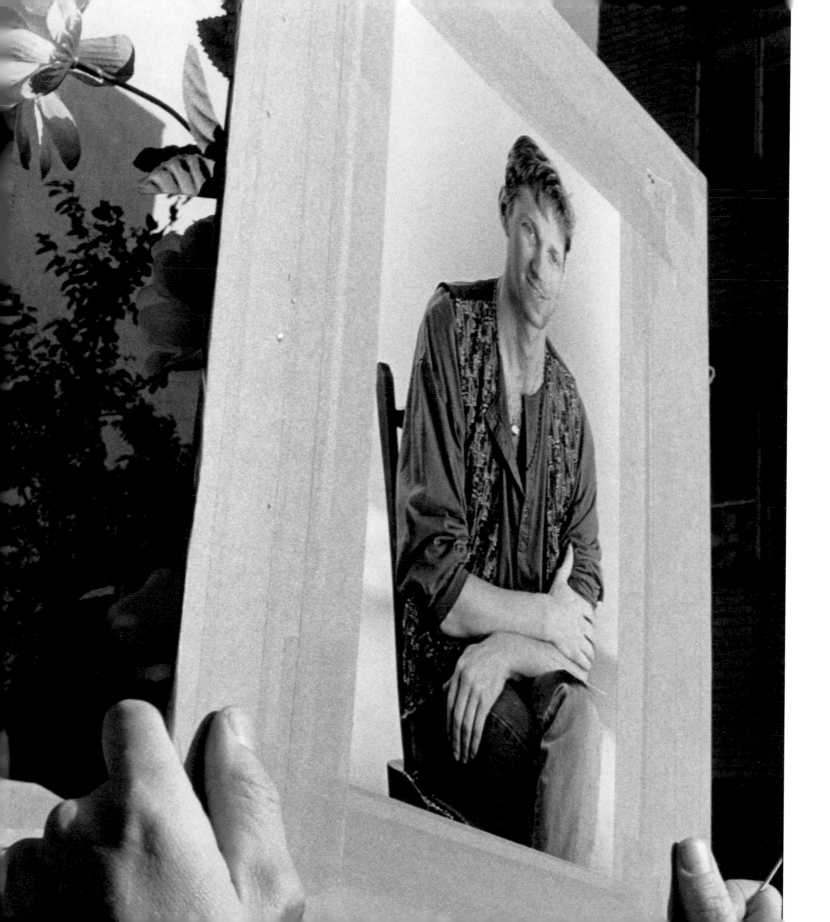

**Willie Sandoval holding photographs of his youngest daughter,
Yakima and granddaughter**
Brooklyn, New York, June 9, 1992

Willie, a former gang leader, addict, and prisoner, was one of those
people you see on the street corner that everyone knows, likes
and respects. After being diagnosed with AIDS, he became an activist,
doing outreach in his neighborhood of Sunset Park, Brooklyn.

About living with AIDS he told me:
**"The worst thing in the world is not *having* AIDS, it's how people
mistreat me because of what I have. It's like racism, it goes real
deep into my heart and mind."**

**"I don't know how the hell I got involved with drugs, but I did.
Sometimes I wonder what happened to me, I was such a good kid!"**

**"I thought AIDS would never happen to me—hey, I'm one of the boys!
Well it did happen not to only one of the boys, but to a lot of the boys.
It's amazing how death swept our neighborhood—I'm still stunned."**

**"Being that I'm on the verge of it, I wonder a lot when I'm going to die...
will it be in the summer or the winter? But whenever it is, I want
to go in style, that would be part of my character."**

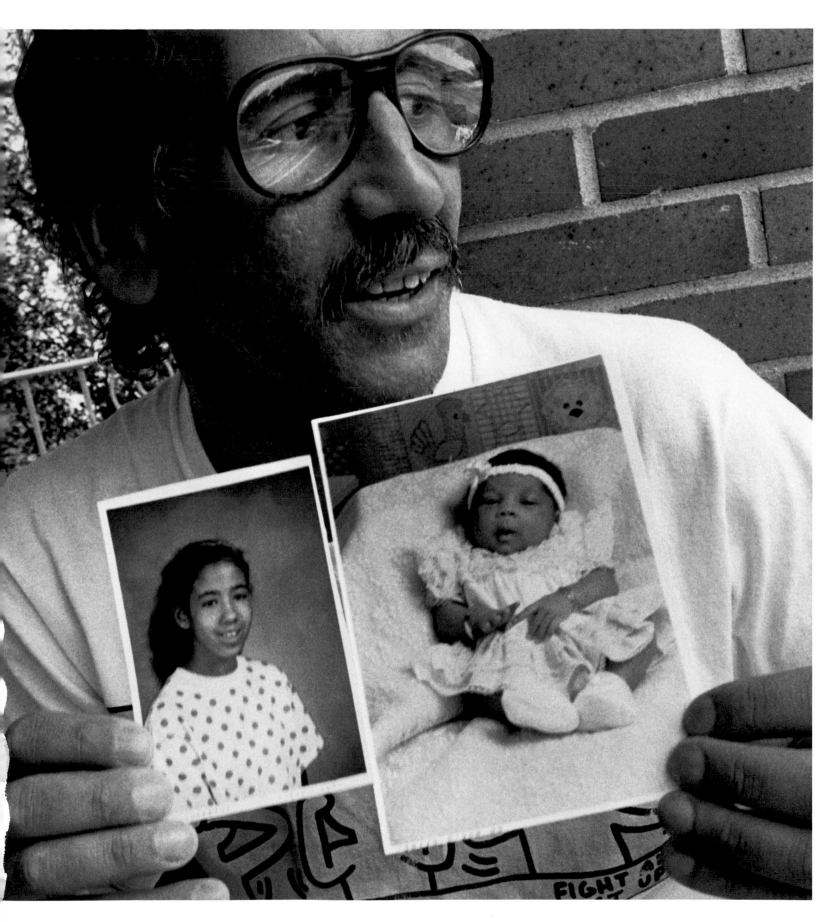

Yakima Sandoval at her father's wake
Brooklyn, New York, September 28, 1992

Willie Sandoval died on September 27, 1992.

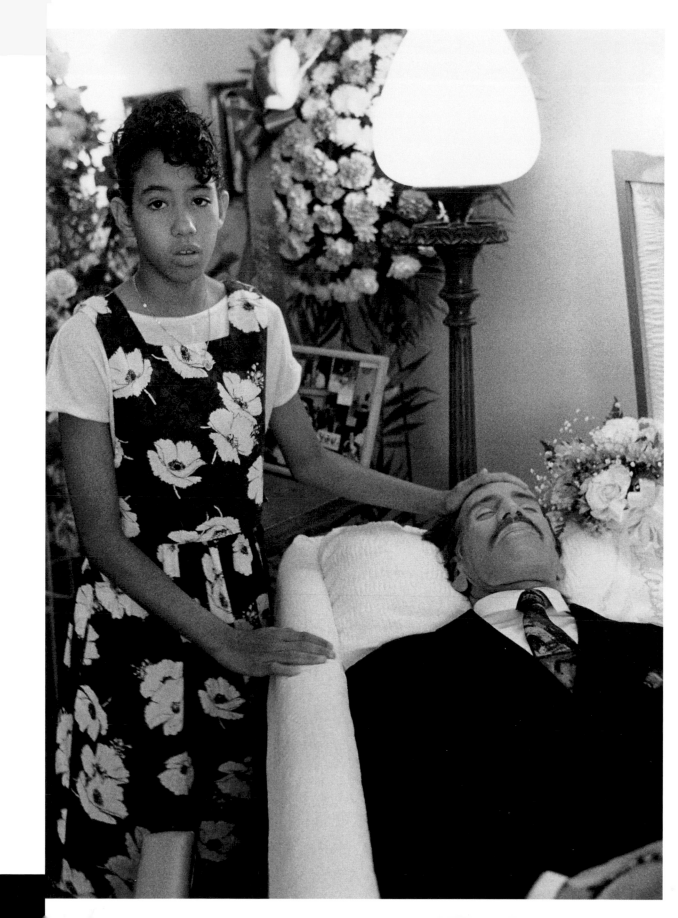

Demonstrator during the Mothers March Against AIDS
Washington, D.C., May 7, 1995

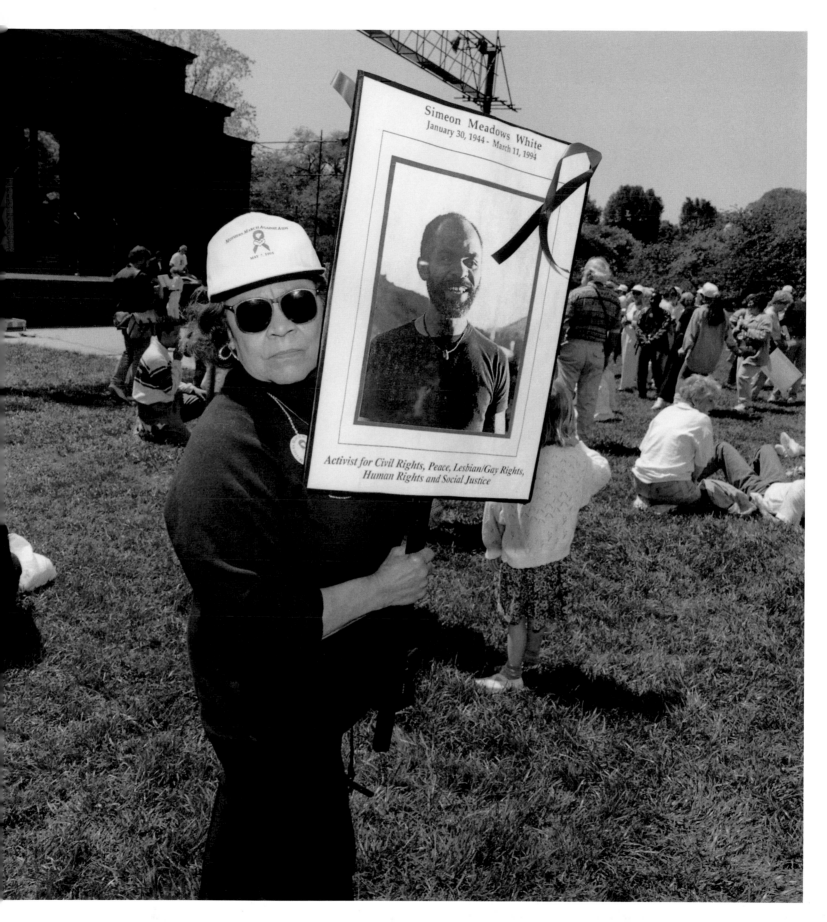

Simeon Meadows White
January 30, 1944 - March 11, 1994

Activist for Civil Rights, Peace, Lesbian/Gay Rights,
Human Rights and Social Justice

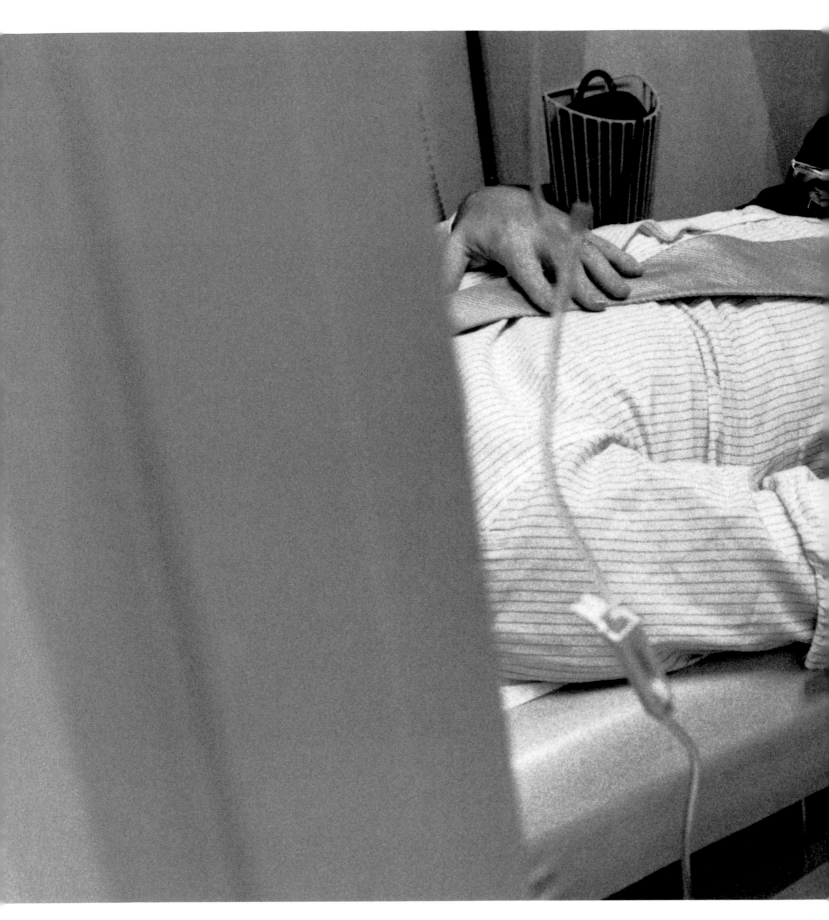

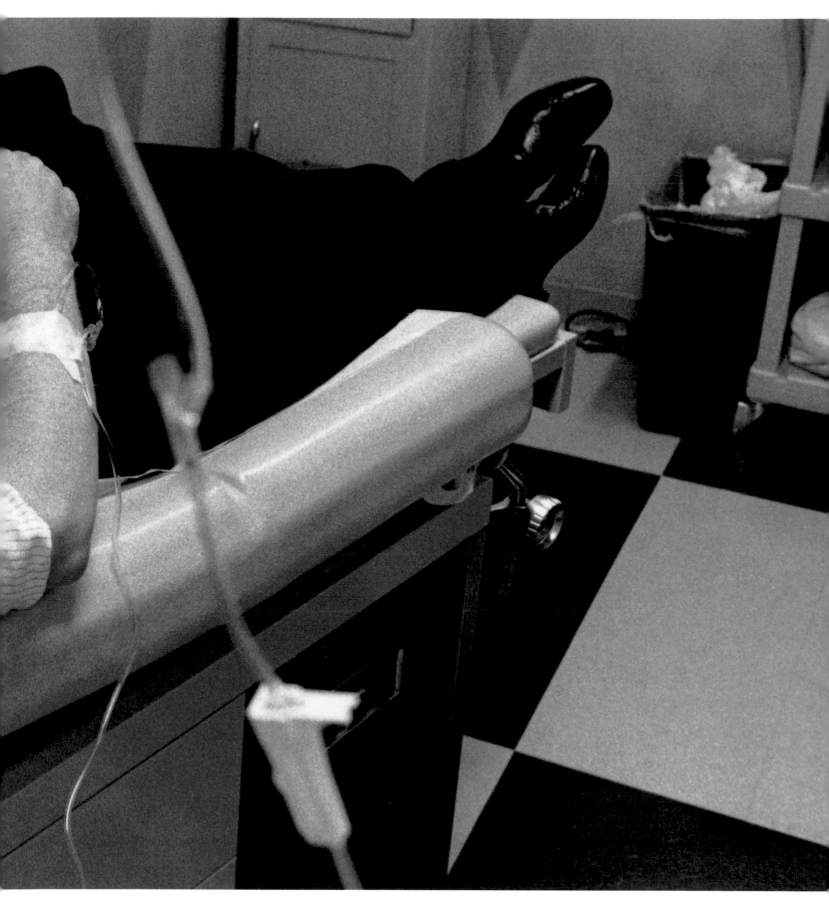

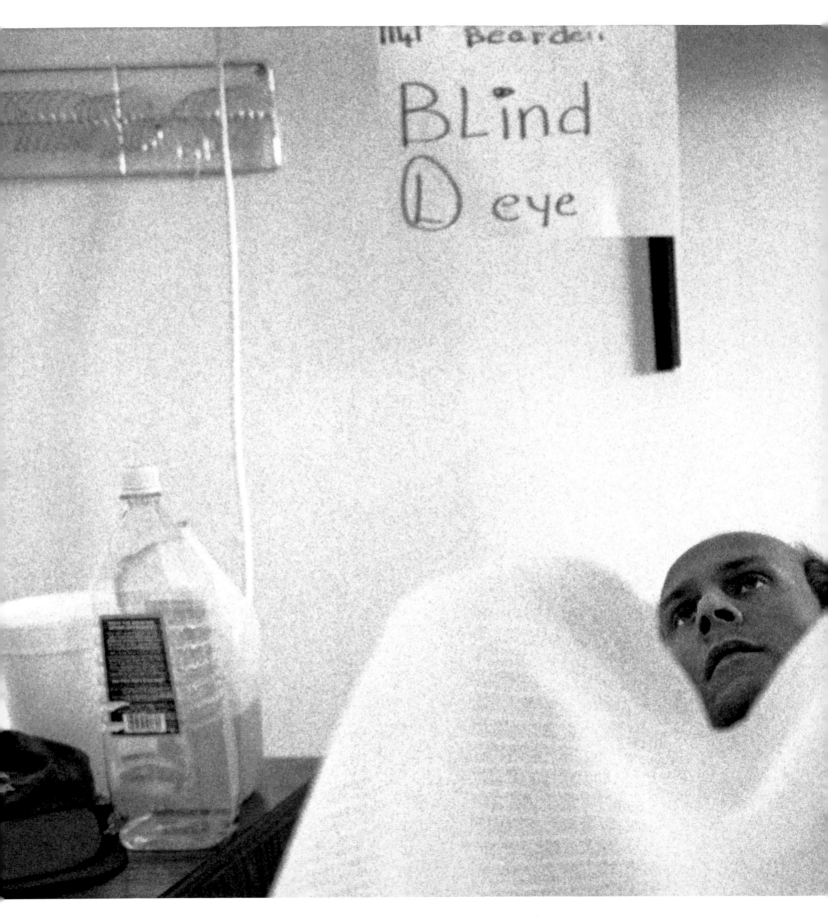

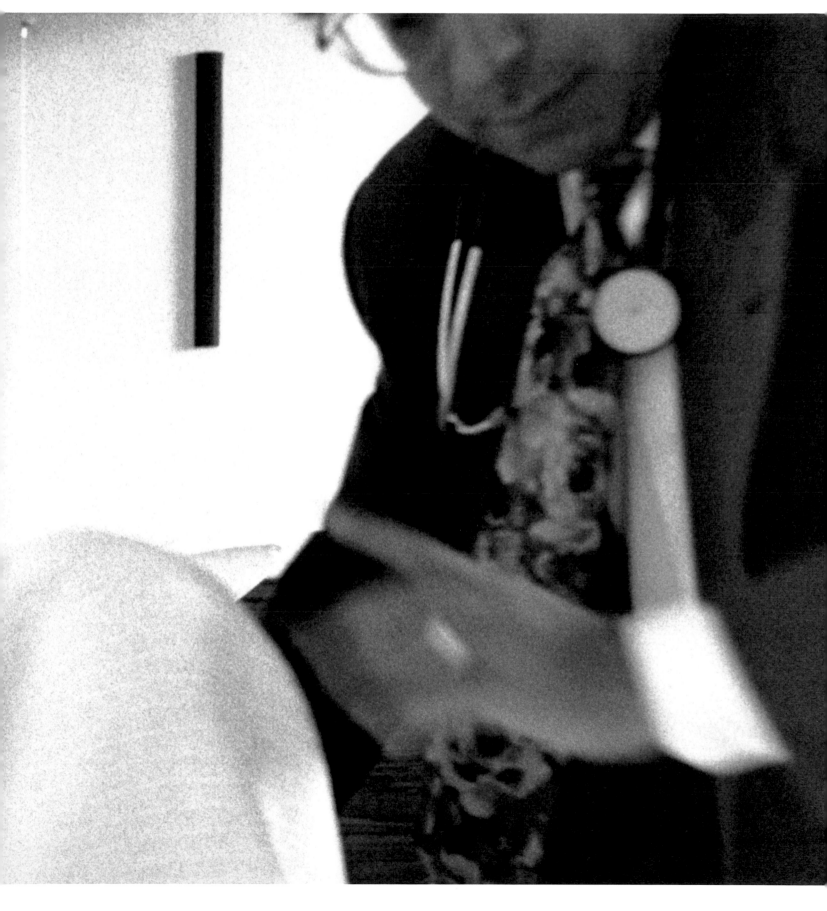

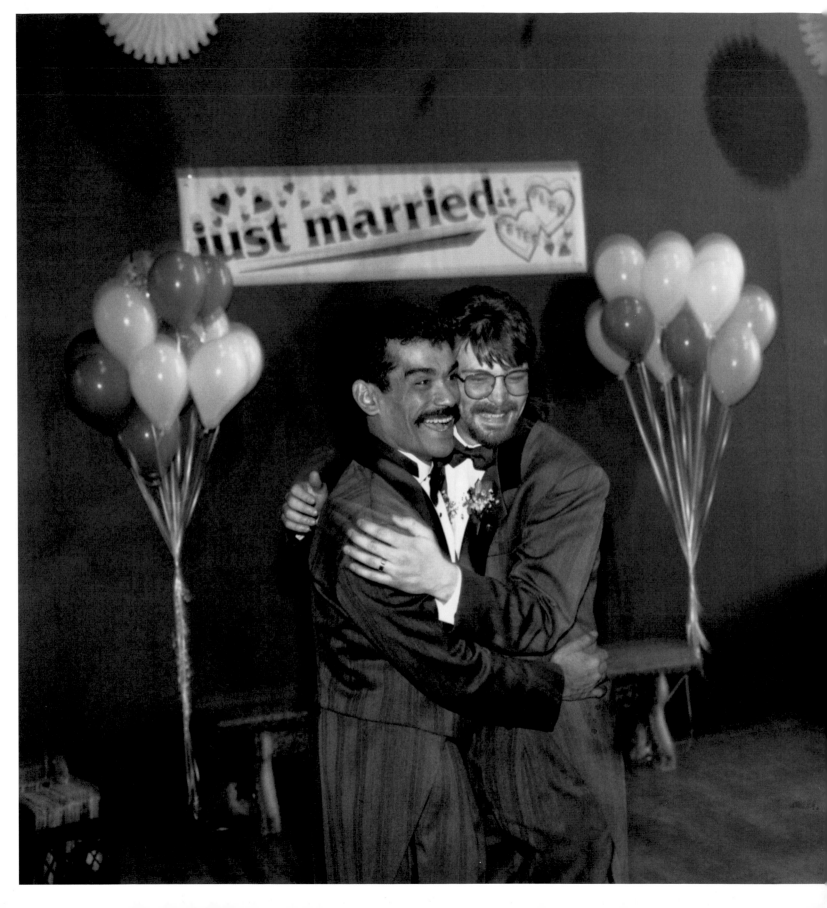

Peter Rodriguez and Glenard Malcolm
Brooklyn, New York, May 15, 1994

I met Peter in 1990 when he was living with his lover, Paul.
Both had AIDS but Peter was the care-giver; extremely attentive,
articulate and a natural organizer. Later, he started a support
group for people with AIDS in Brooklyn and was co-founder
of GLOBE, a support group for the borough's gays and lesbians.

Paul died in 1991.

Peter met Glen, who is HIV– negative, and they were formally
joined at St. Ann's Church in Brooklyn on May 15, 1994.

18, 19.
Activist James Baggett during an AIDS demonstration at New York City Hall, March 22, 1994.

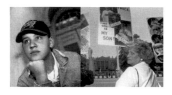

34.
Grant Lewis, 14, from Licking, Missouri, is a peer educator and the only person in his small town that has AIDS, March 30, 1995.

35.
Grant's mother, Linda, in front of the White House during the Mothers March Against AIDS, May 7, 1995.

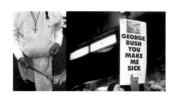

46.
Priest at an annual candlelight vigil for people who have died from AIDS, New York City, 1992.

47.
ACT UP demonstration during a political fund-raiser, New York City, 1991.

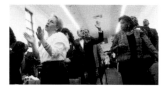

52, 53.
Donna Martinez, born-again Christian with AIDS, worshipping on Christmas Day, Brooklyn. New York, 1994.

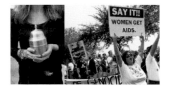

58, 59.
Demonstrators during an AIDS rally in Washington, D.C., November, 1992. The event ended with human ashes being thrown onto the White House lawn.

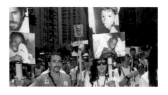

64, 65.
Marchers in New York's Gay Pride Parade carry photographs of people who have died from AIDS, June 26, 1994.

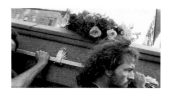

76, 77.
Activist James Baggett and friends carry the coffin of fellow activist, Jon Greenberg, through the streets of New York City during a political funeral, July 16, 1993. Jon Greenberg died on July 12, 1993.

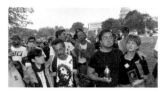

84, 85.
Marchers at the start of an AIDS demonstration, Washington, D.C., November, 1992.

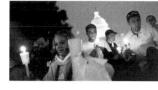

86, 87.
Marchers during a candlelight vigil in Washington, D.C., October 12, 1996.

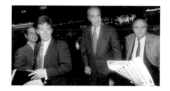

100, 101.
Republican Presidential candidate, Senator Bob Dole, being handed literature by an AIDS activist while entering a political fundraiser, New York City, December 6, 1994.

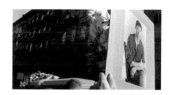

110, 111.
Political funeral for AIDS activist Jon Greenberg, who died from the disease in New York on July 12, 1993.

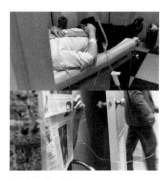

118, 119, 120, 121.
Patients receiving Compound Q, an experimental AIDS drug that was smuggled into the U.S. from China. The drug had no effect. New York City, June, 1991.

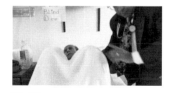

122, 123.
Dr. Jeffrey Wallach examining patient Al Bearden, New York City, June 1991.

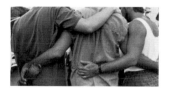

126, 127.
Friends consoling one another at the political funeral for Jon Greenberg, New York City, July 16, 1993.